Remembering
Indianapolis

George R. Hanlin

TURNER
PUBLISHING COMPANY

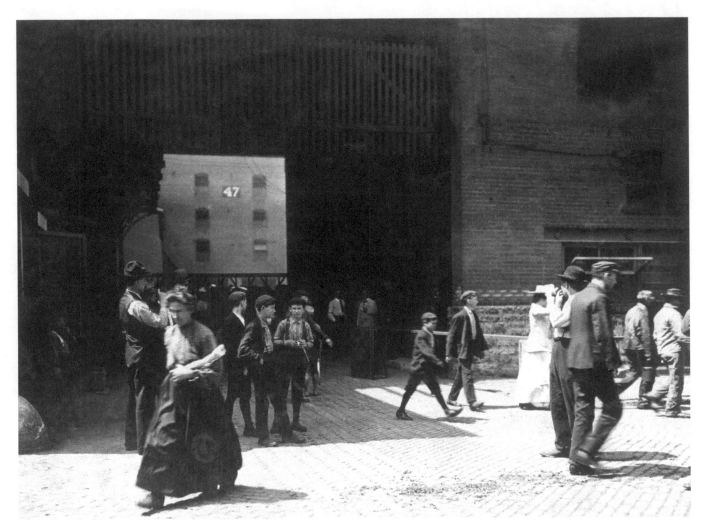

Noon hour at an Indianapolis meatpacking house, 1908. Kingan and Company, located at Maryland and Blackford streets along the White River, was the city's largest meatpacking plant. Lewis Hine, who traveled around the country documenting child laborers, visited Indianapolis in August 1908 and likely took this photo there.

Remembering
Indianapolis

Turner Publishing Company
4507 Charlotte Avenue • Suite 100
Nashville, Tennessee 37209
(615) 255-2665

Remembering Indianapolis

www.turnerpublishing.com

Library of Congress Control Number: 2010902281

ISBN: 978-1-59652-608-2

Printed in the United States of America

ISBN: 978-1-68336-841-0 (pbk)

10 11 12 13 14 15 16—0 9 8 7 6 5 4 3 2 1

CONTENTS

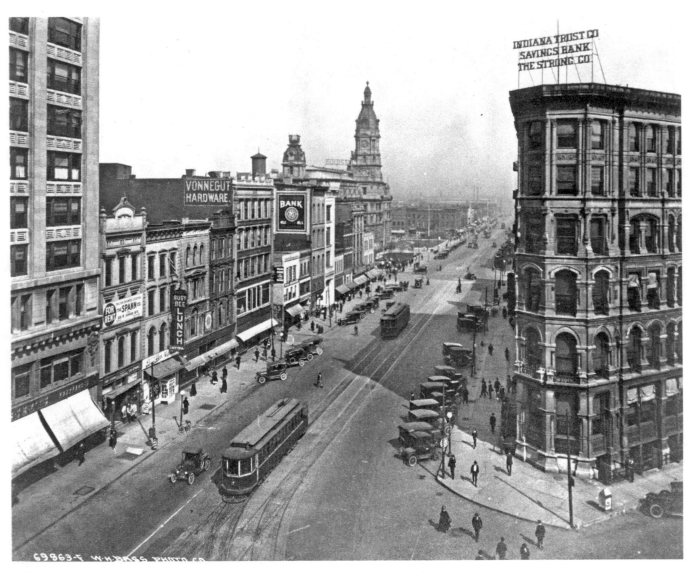

Washington Street, looking east from the intersection of Pennsylvania Street and Virginia Avenue, circa 1920.

Acknowledgments

This volume, *Remembering Indianapolis,* is the result of the cooperation and efforts of several individuals and organizations. It is with great thanks that we acknowledge the valuable contribution of the following for their generous support.

Buchanan Group
Indiana Historical Society
Indiana Power and Light
Indiana State Library
Library of Congress

We would also like to express our gratitude to Marcia Caudell, Joan Hostetler, Susan Sutton, and Elizabeth Wilkinson for providing research and assisting the writer.

PREFACE

Indianapolis has thousands of historic photographs that reside in archives, both locally and nationally. This book began with the observation that, while those photographs are of great interest to many, often they are not easily accessible. During a time when Indianapolis is looking ahead and evaluating its future course, many people are asking, How do we treat the past? These decisions affect every aspect of the city—architecture, public spaces, commerce, tourism, recreation, and infrastructure—and these, in turn, affect the way that people live their lives. This book seeks to provide easy access to a valuable, objective look into the history of this great city.

With the exception of touching up imperfections that have accrued with the passage of time and cropping where necessary, no changes have been made. The focus and clarity of many images is limited by the technology and the ability of the photographer at the time they were taken.

This project represents countless hours of research and review. The researchers and writer have reviewed thousands of photographs in numerous archives. We greatly appreciate the generous assistance of the archivists listed in the acknowledgments of this work, without whom this project could not have been completed.

The goal in publishing this work is to provide broader access to a set of extraordinary photographs that seek to inspire, provide perspective, and evoke insight that might assist people who are responsible for determining Indianapolis's future. In addition, the book seeks to preserve the past with adequate respect and reverence.

The photographs selected have been reproduced in dramatic black-and-white tones to provide depth to the images. With the exception of touching up imperfections that have accrued with the passage of time and cropping where necessary, no changes have been made. The focus and clarity of many images are limited to the technology and the ability of the photographer at the time they were recorded.

The work is divided into eras. Beginning with some of the earliest known photographs of Indianapolis,

the first section records photographs from the Civil War through the end of the nineteenth century. The second section spans the beginning of the twentieth century to the end of World War I. Section three moves from the 1920s to the 1930s. And finally, section four covers the 1940s to the 1960s.

In each of these sections we have made an effort to capture various aspects of life through our selection of photographs. People, commerce, transportation, infrastructure, religious institutions, educational institutions, and scenes of natural beauty have been included to provide a broad perspective.

We encourage readers to reflect as they traverse the streets of downtown, stroll along Monument Circle, or peer into the city's many shops and venues. Electric streetcars once traveled throughout the city, farms were in abundance, and many buildings, long since demolished, stood where newer buildings of the late twentieth century stand today. It is hoped that in utilizing this work, longtime residents will learn something new and that new residents will gain a perspective on where Indianapolis has been, so that each can contribute to its future.

—Todd Bottorff, Publisher

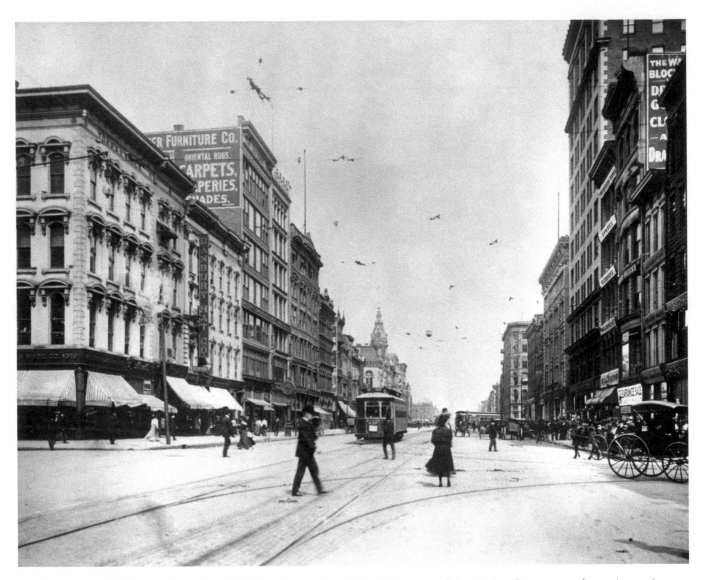

Looking east on Washington Street from Meridian Street, circa 1890s. The tower of the Marion County courthouse is seen in the distance.

Out of the Wilderness

(1860–1899)

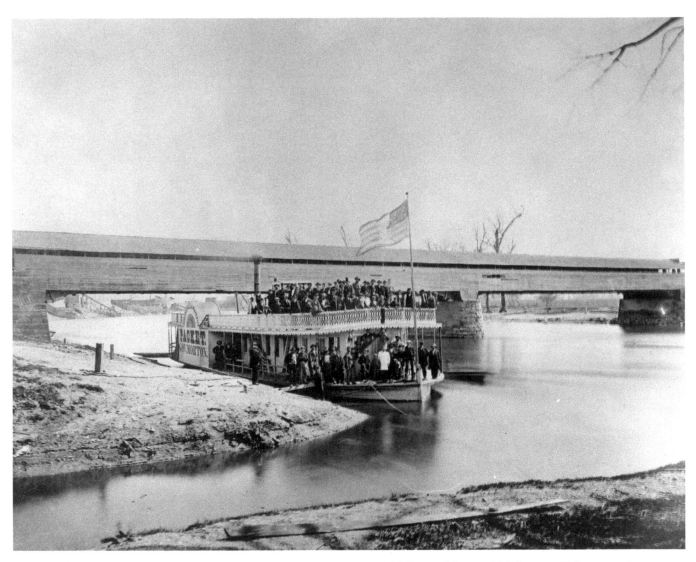

Indianapolis residents enjoy a trip on the packet *Governor Morton* in 1866. The small boat, which began offering excursions on the White River at the end of the Civil War, sank not long after this photograph was taken. In the background is the old National Road (Washington Street) covered bridge, which carried travelers across the river from 1834 until 1902.

Workers at the Nordyke and Marmon Company, circa 1886. Ellis Nordyke founded the company in Richmond, Indiana, in 1851, and his son relocated it to an area called West Indianapolis in 1876. The company manufactured mill equipment and later automobiles. The Marmon Wasp won the first Indianapolis 500 in 1911.

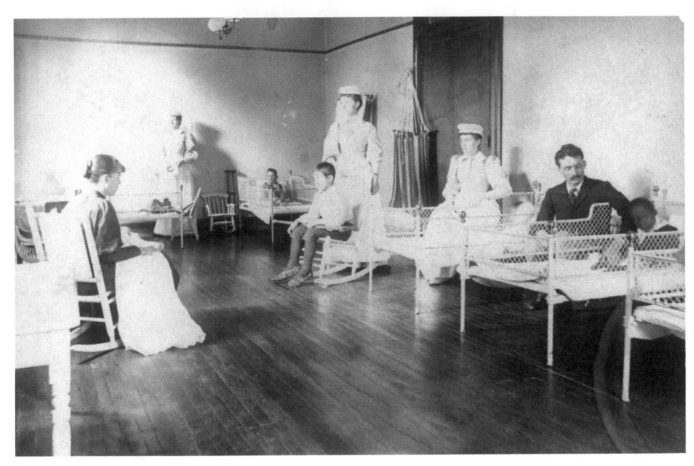

The children's ward of the Indianapolis City Hospital, 1887. The city built the charity hospital in the mid-1850s but did not take responsibility for operating it until after the Civil War. While services were lacking in the early years, conditions improved greatly under the leadership of William Niles Wishard, Sr., the hospital's administrator from 1879 to 1886. Today the hospital carries Wishard's name and is managed by the Indiana University School of Medicine.

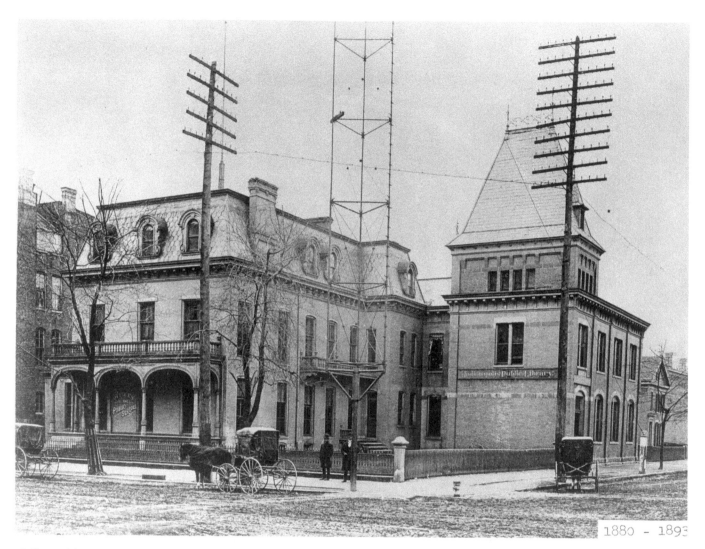

1880 - 1893

Offices of the Indianapolis School Board and Indianapolis Public Library, circa 1880s. Indianapolis's library opened in 1873. In 1880 it moved to this site, the former Alvord House on the corner of Pennsylvania and Ohio streets, and remained there until 1893. Today the central library's permanent home, a 1917 Greek Doric structure on St. Clair Street, is undergoing renovation and expansion. The library is also served by 22 branch locations.

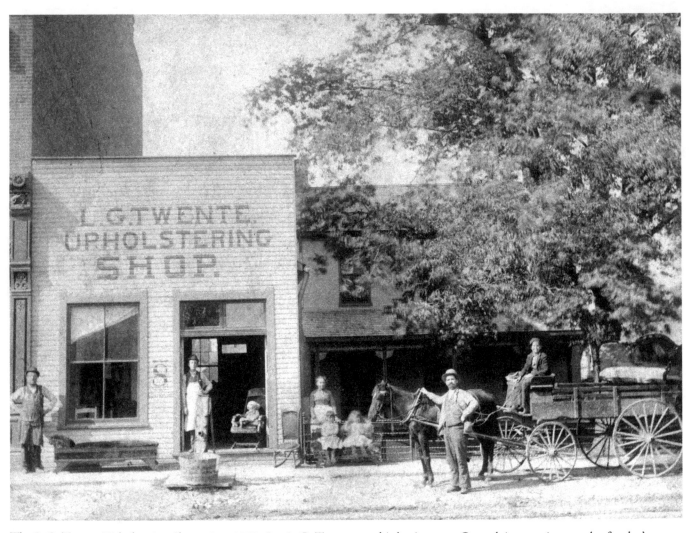

The L.G. Twente Upholstering Shop, circa 1880. Louis G. Twente ran this business on Central Avenue, just north of today's Tenth Street.

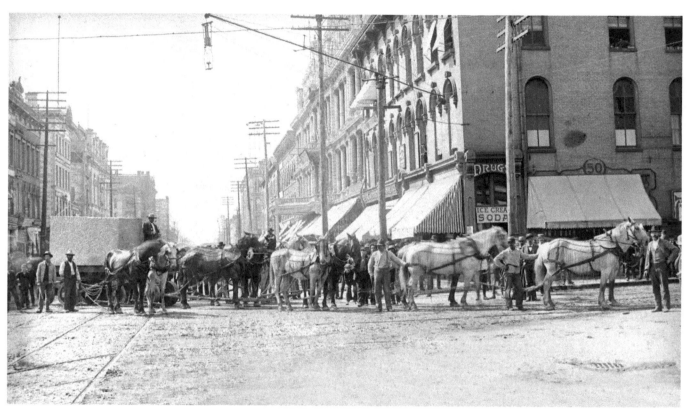

Teams of horses pull stone to the Soldiers and Sailors Monument construction site, circa 1890.

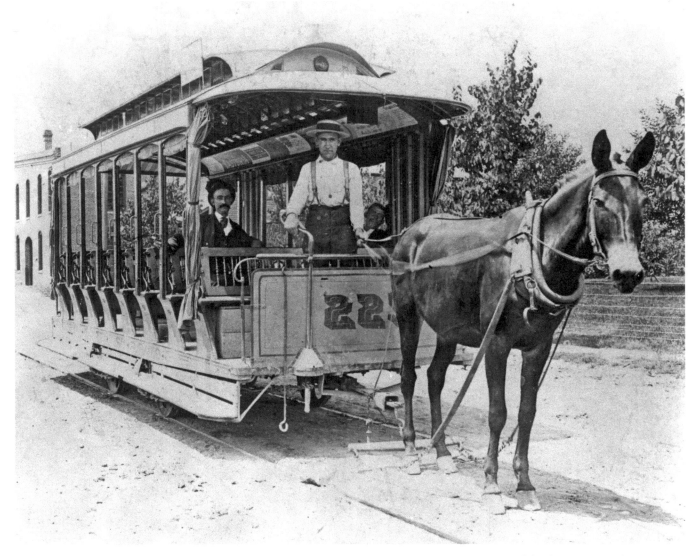

A mule-drawn streetcar on McCarty Street, circa 1890. Behind the reins is Ira Bartholomew, one of the first streetcar drivers in Indianapolis. Mules pulled cars along the city's streets from 1864 until 1894, when electric cars finally phased them out.

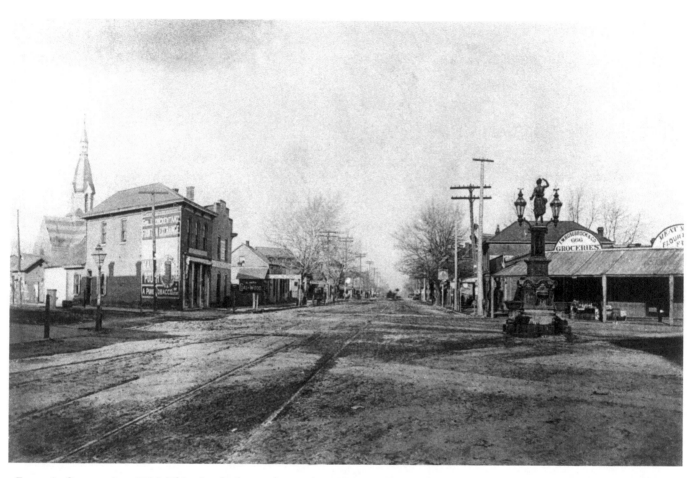

Fountain Square, circa 1890. This view looks northwest along Virginia Avenue, from where it intersects with Prospect and Shelby streets. The fountain to the right was built in 1889 and is the namesake for the surrounding neighborhood. It stood for about 30 years until, legend states, wind caught an advertising banner attached to it and toppled it. A new fountain took its place in 1924.

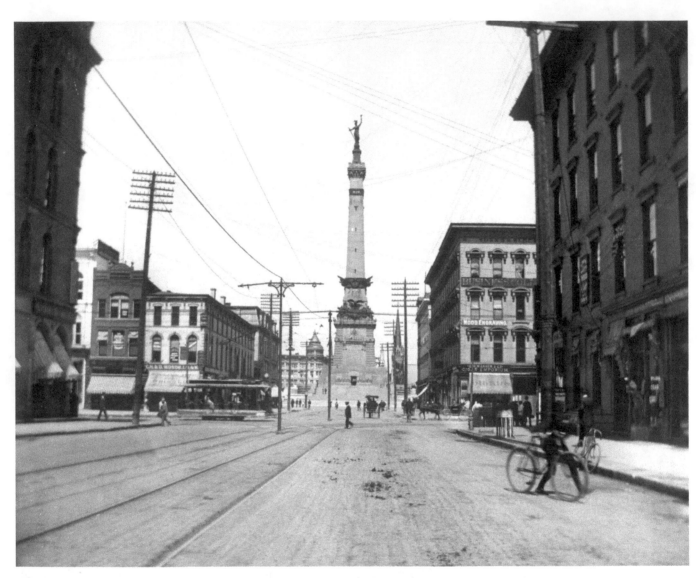

A view of the Soldiers and Sailors Monument from South Meridian Street in the mid-1890s. Note the bicyclists to the right. Indianapolis saw its first safety bicycles in 1889, and according to the *Encyclopedia of Indianapolis*, by the early 1890s "so many bicycles clogged the streets that in 1893 the City Council passed an ordinance requiring a $1 license fee."

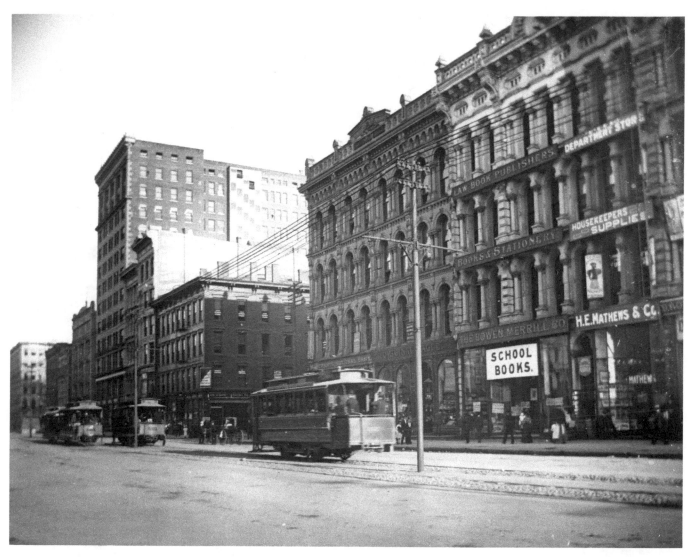

A streetcar passes by the Bowen-Merrill Company on West Washington Street, circa 1898. Bowen-Merrill was a publishing company with Indianapolis roots dating to the 1850s. In 1903, it became known as Bobbs-Merrill and was noted for publishing the work of Indiana authors such as James Whitcomb Riley and Meredith Nicholson. By the 1940s it was the largest general publisher west of the Alleghenies. Among the noted works it introduced were Irma Rombauer's *Joy of Cooking*, Ayn Rand's *The Fountainhead*, and William Stryon's *Lie Down in Darkness*. After various company buyouts over the years, the Bobbs-Merrill imprint disappeared by the mid-1980s.

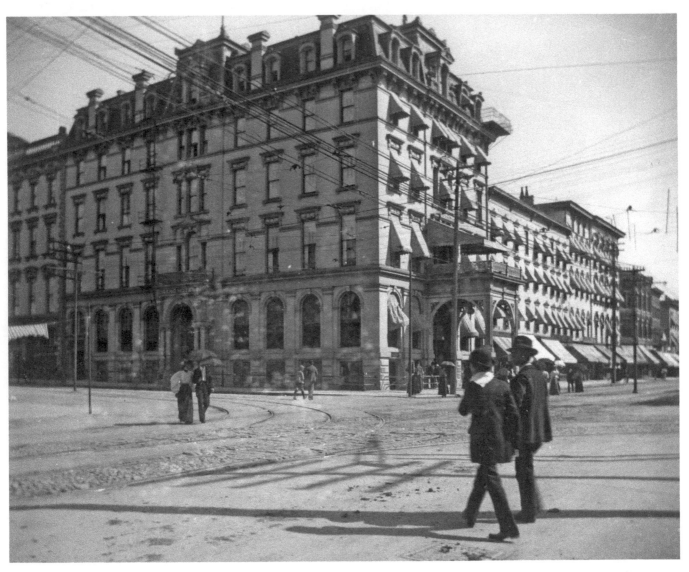

The Grand Hotel, circa 1890s. The hotel stood on the southeast corner of Illinois and Maryland streets. When it opened in 1875 it was one of the finest in the city.

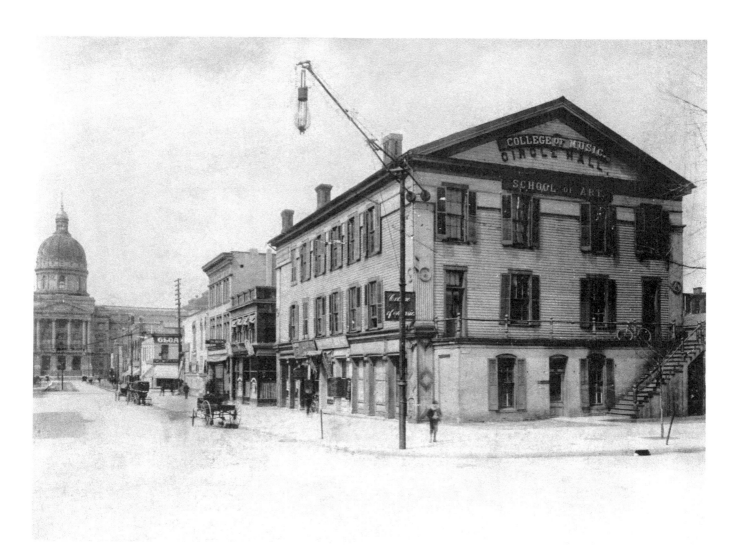

Circle Hall, circa mid-1890s. This structure, built in 1840, originally served as the home of Henry Ward Beecher's Second Presbyterian Church. When the church moved after the Civil War, the building was used as a school. By the 1890s it was known as Circle Hall and housed the city's College of Music and the second Indiana School of Art. It was torn down to make way for the expansion of the English Hotel in 1896.

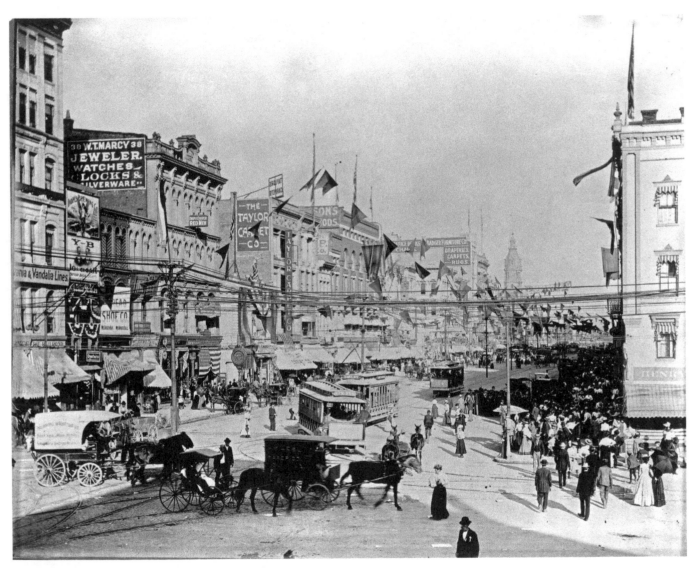

Washington Street, looking east from Illinois Street. Indianapolis historian Jerry Marlette dates the photo to the summer of 1891 and indicates that the flags and bunting are hung to celebrate a convention of the National Association for Democratic Clubs.

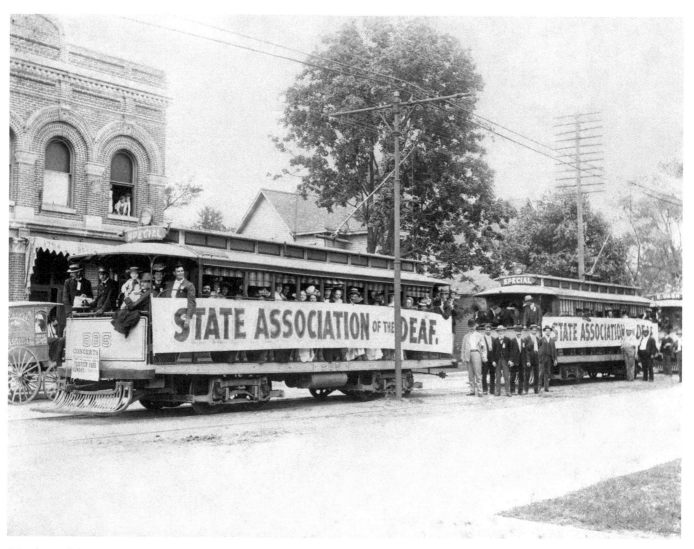

Members of the State Association of the Deaf participate in a streetcar parade, circa 1890s. In 1843, the Indiana General Assembly passed legislation allowing for the establishment of a state-run deaf school, and in 1850 the first permanent campus opened on Indianapolis's east side, near Washington Street and State Avenue. In 1905, the school moved to its current location on Forty-second Street, north of the state fairgrounds.

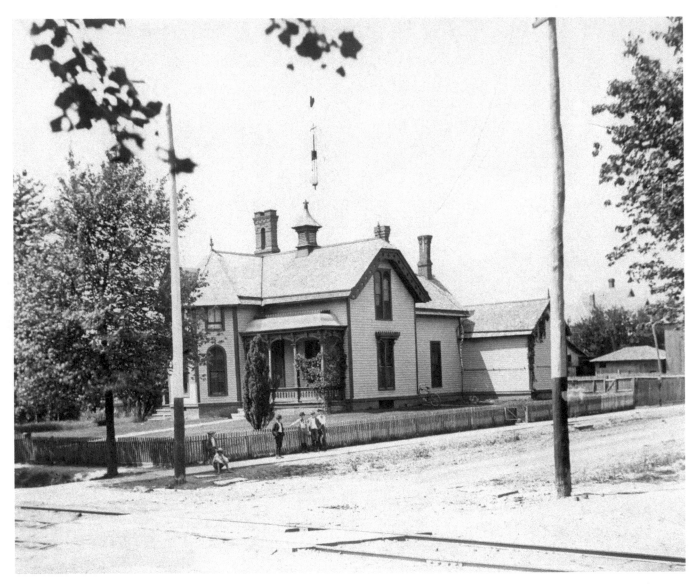

An example of an Indianapolis home around the late nineteenth century. After the Civil War many middle-class and wealthy residents built new houses on the outskirts of the growing city, and Indianapolis adopted the moniker "City of Homes."

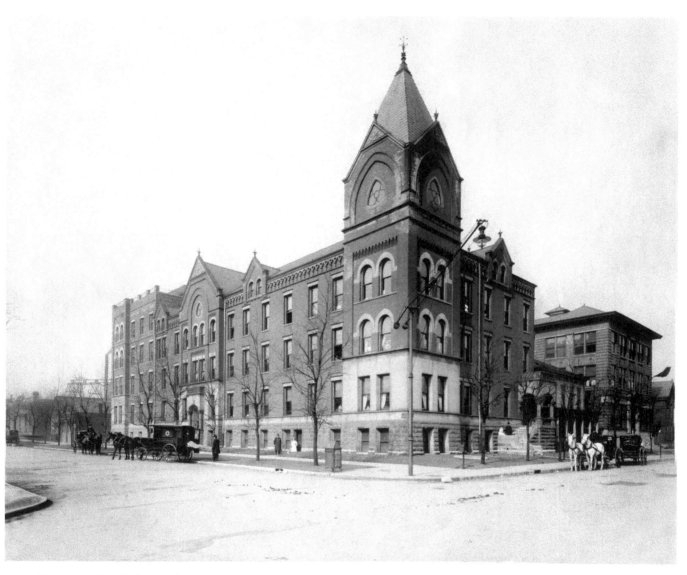

Deaconess Hospital around the time it opened in 1899 Deaconess stood on the northwest corner of Ohio Street and Senate Avenue. It closed in 1935 because of financial difficulties.

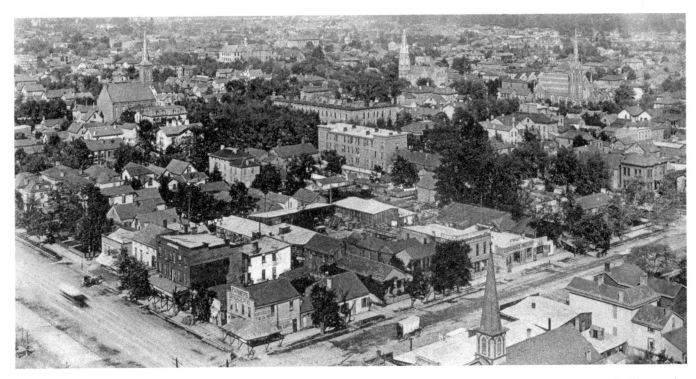

Looking northeast from the Marion County courthouse, late 1880s. This image appeared in a book titled *Indianapolis Illustrated*, published in 1889.

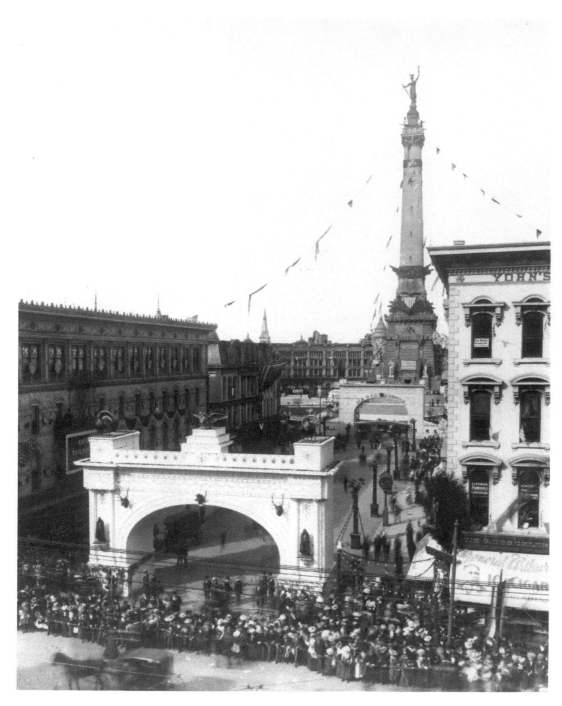

A city carnival, October 1903. According to historian Edward Leary, downtown merchants sponsored the weeklong festivities, which took place in the shadows of these arches spanning Meridian Street. The carnival included daily parades, a midway on New Jersey Street, and, Leary writes, "Galarno, the Human Fly, who climbed the Soldiers and Sailors Monument and took bows on the arm of Miss Indiana."

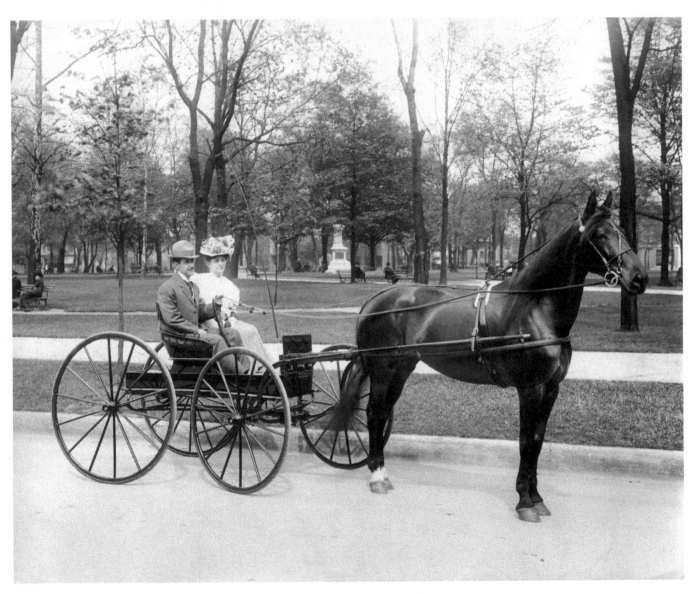

A couple enjoys a carriage ride, early 1900s. The two are passing University Park downtown.

Monumental Celebrations

(1900–1919)

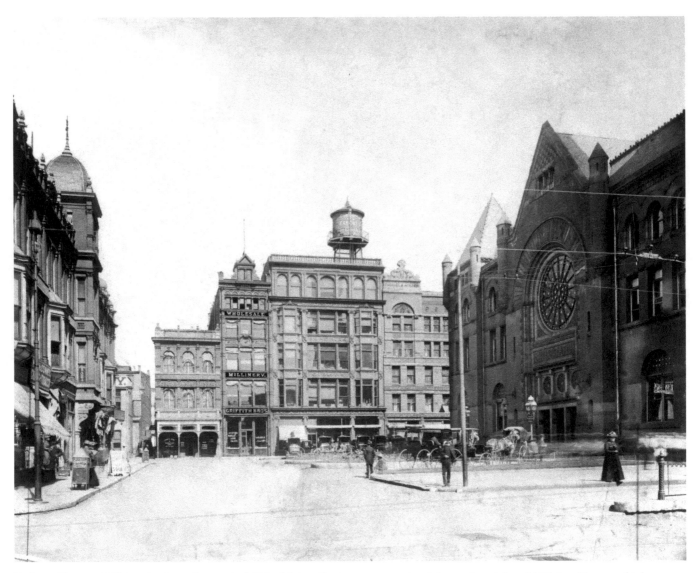

Jackson Place and Union Station, circa early 1900s. Union Station, seen on the right, replaced the old Union Depot, which was the first station in the country to serve multiple independent rail lines. In the early twentieth century some 200 passenger trains arrived and departed daily from the station.

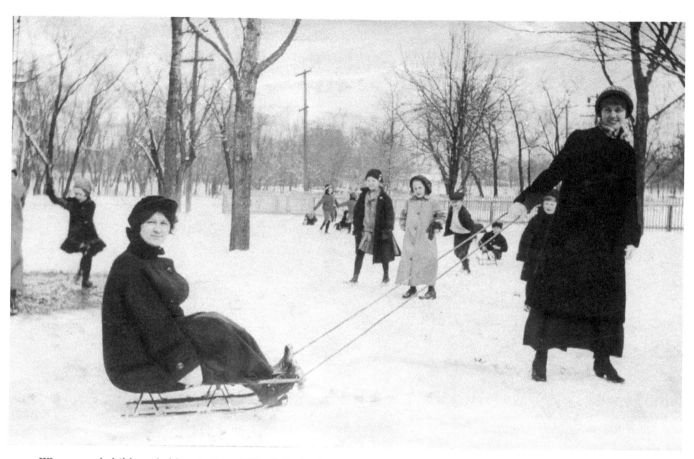

Women and children sledding in Broad Ripple Park, circa 1910s. The park, located on the city's north side, featured popular amusement attractions from 1906 until the mid-1940s.

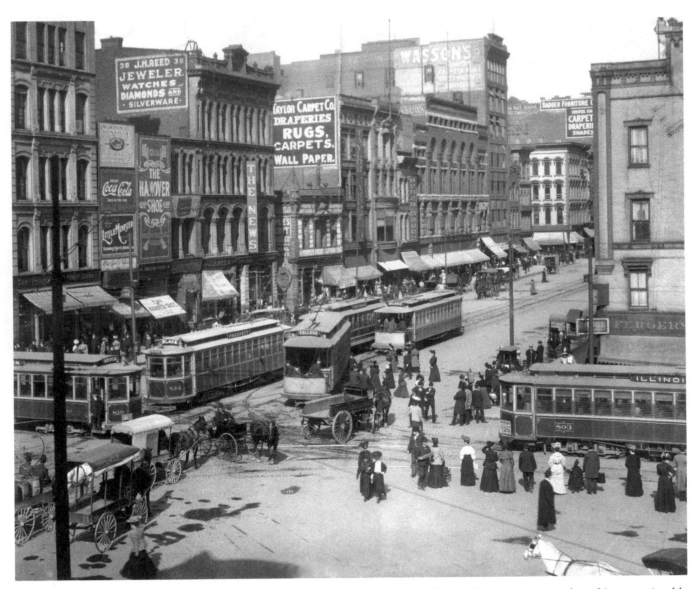

Washington and Illinois streets, circa 1905. In the days before stoplights, busy Indianapolis intersections such as this were a jumble of streetcars and horse-drawn wagons and carriages.

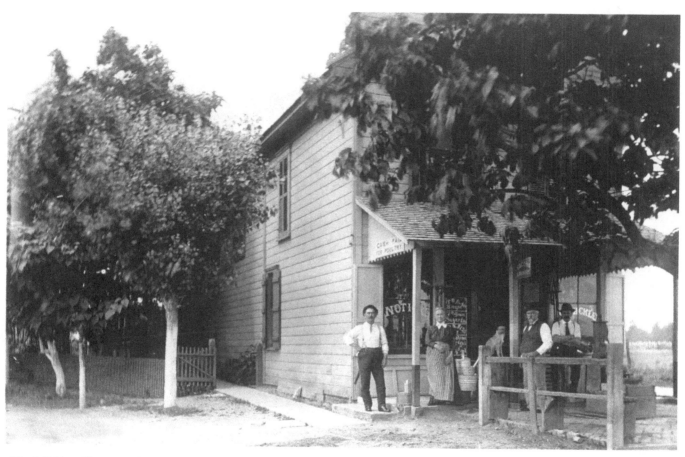

The Mickleyville General Store, circa 1905. Mickleyville was located west of Indianapolis, off the National Road (near the I-465–Washington Street interchange today).

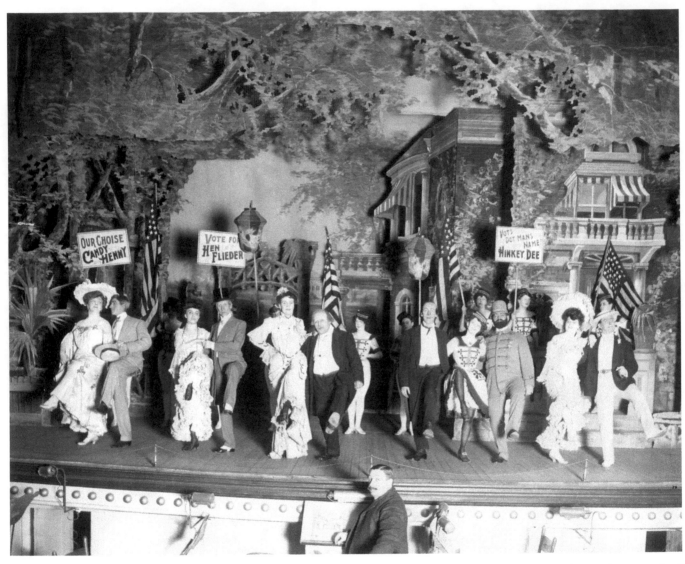

An early-twentieth-century production at the Empire Theater. The Empire was located on the east side of Delaware Street north of Market Street. It opened in 1892 and was renamed the Columbia Theater in 1913.

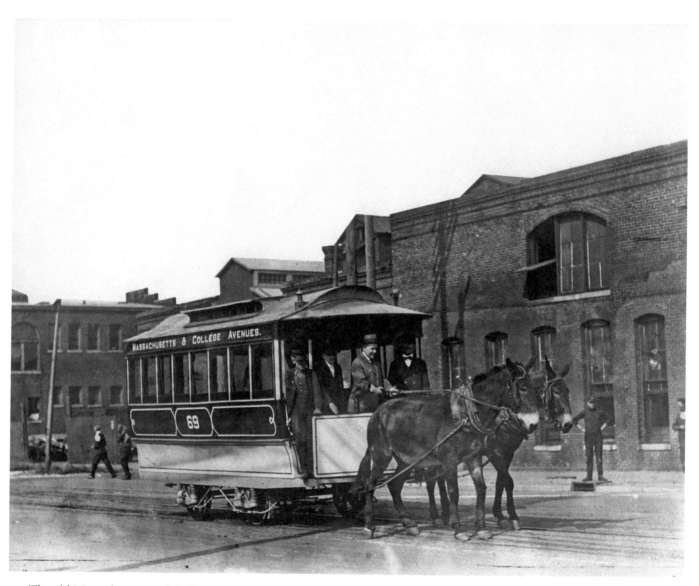

The old Massachusetts and College avenues streetcar, circa late 1910s. Indianapolis's street railway company kept its prized No. 69 car and displayed it frequently. Here officials give it an "airing" on West Washington Street. The old car shops are seen in the background. The era of the mule-drawn streetcar ended in 1894.

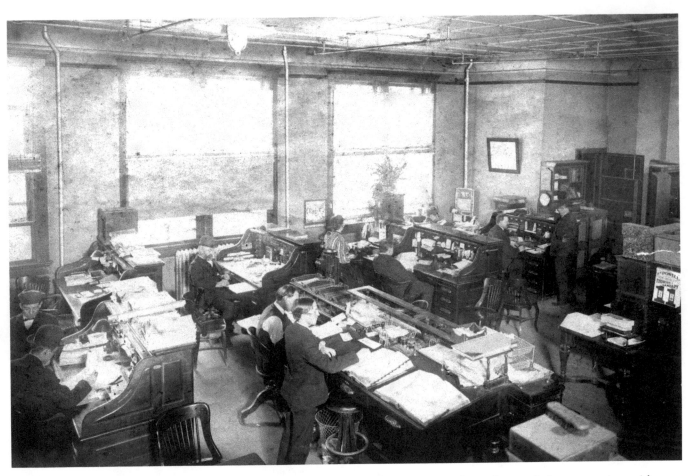

Workers in the Nordyke and Marmon Company offices. Male employees dominate in this early-twentieth-century view, with a lone woman working along the windows.

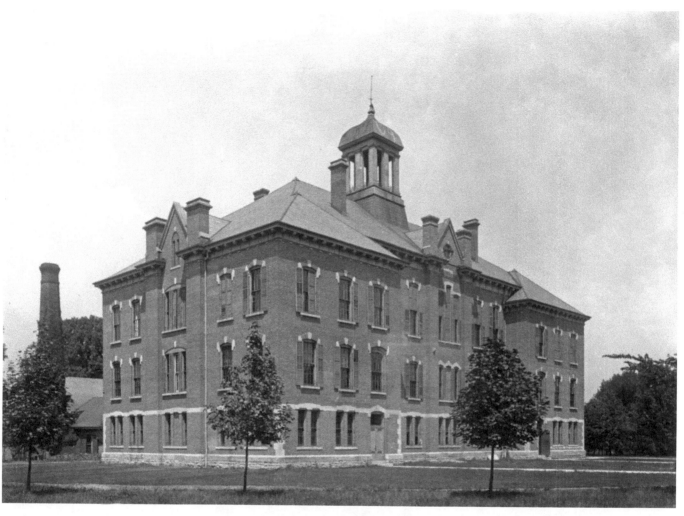

The administration building at Butler University, 1904. The Christian Church (Disciples of Christ) opened the school as North Western Christian University in 1855 at what is now College Avenue and Thirteenth Street. In 1875, the trustees moved the campus to the east-side suburb of Irvington, where this photograph was taken, and two years later they renamed it to honor longtime leader and benefactor Ovid Butler. In 1928 the university moved to its current location on the city's north side, where it has become one of the Midwest's leading private liberal-arts schools.

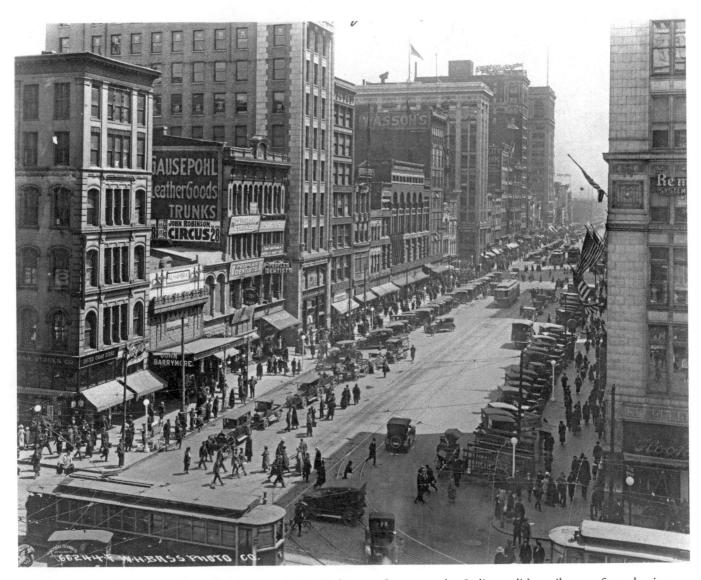

Washington Street looking east from Illinois Street, 1919. Washington Street served as Indianapolis's retail center from the time of the city's founding until suburban shopping malls began drawing away business in the late 1950s. This early-twentieth-century photograph shows the crowds that used to flock to its department stores, shops, hotels, and theaters.

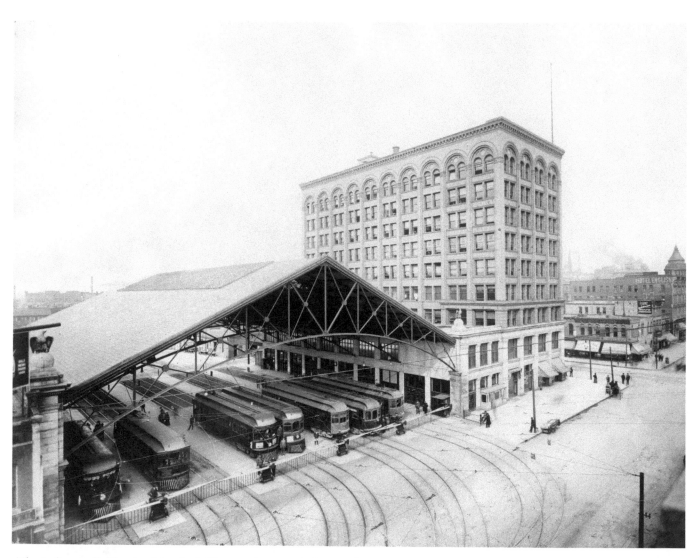

The Indianapolis Traction Terminal. The traction terminal opened in 1904 on the northwest corner of Illinois and Market streets, just east of the state capitol. It served as a station for the numerous interurban trains that traveled across the state in the first three decades of the twentieth century. The shed covered nine tracks and the terminal building held 250 offices, making the complex the largest of its kind in the world. The shed was torn down in 1968 and the terminal building in 1972. Two stone eagles that graced the south side of the shed still remain, relocated to the former city hall on Alabama Street.

A view of the traction
terminal from the east.
The firm of Chicago
architect Daniel
Burnham designed the
nine-story building.

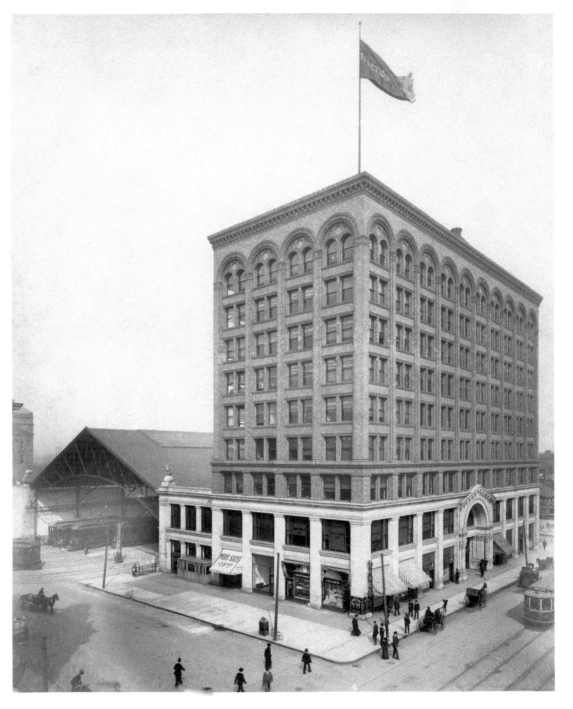

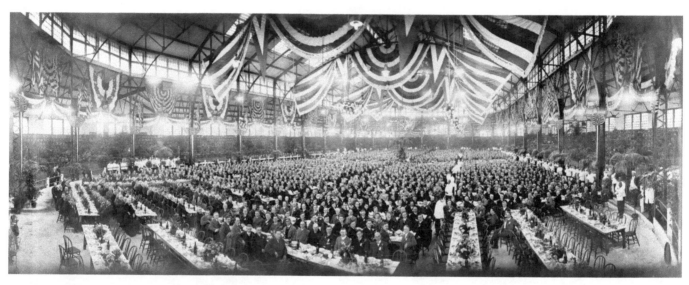

Members of the Ancient Accepted Scottish Rite celebrate the organization's golden jubilee, May 19, 1915. The celebration took place at the Indiana state fairgrounds coliseum.

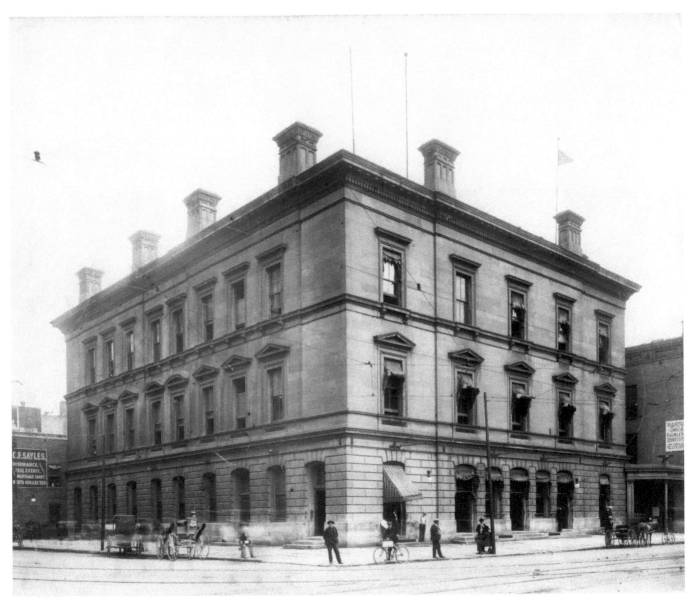

The old federal building, 1905. Completed in 1860, this was the first federal building in Indianapolis. It stood on the southeast corner of Pennsylvania and Market streets and housed the post office and federal courtrooms. Though it was expanded in the mid-1870s, it quickly ran out of space, so the government constructed a new federal building at Meridian and Ohio streets in the early 1900s. Afterward this structure served as a bank.

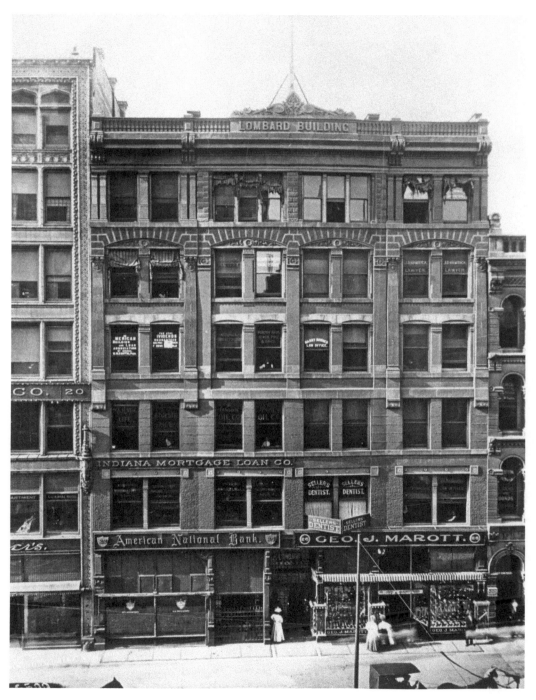

The Lombard building, circa 1905. Architect Robert Platt Daggett designed this building, which was constructed in 1893 on the north side of Washington Street between Meridian and Pennsylvania streets. Now renamed the Victoria Centre, it is listed on the National Register of Historic Places.

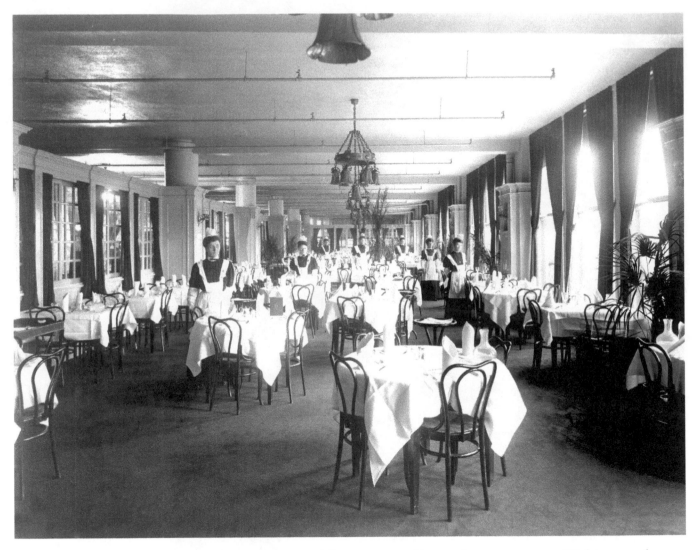

The L. S. Ayres tea room, circa 1905. When L. S. Ayres and Company opened its new department store at Washington and Meridian streets in 1905, it included a tea room on the fifth floor, where shoppers could rest and have a meal. Years later the tea room relocated to the top floor, the eighth. Many Hoosiers still recall with fondness its chicken velvet soup and children's toy chest. Though Ayres is now gone, the Indiana State Museum has re-created the tea room, giving visitors the chance to once again enjoy its recipes and relive a bit of the Ayres experience.

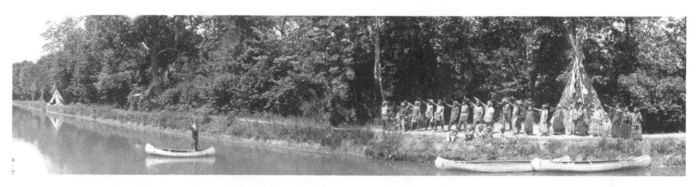

Members of the Ojibway tribe perform a dramatization of Henry Wadsworth Longfellow's "Song of Hiawatha," 1913. Performances ran from July 4 through July 9 and took place along the old Central Canal at Fairview Park, today the site of Butler University. According to the *Indianapolis Star,* proceeds from the show were to benefit the Summer Mission for Sick Children, a "fresh air" mission that worked to improve the health and general well-being of impoverished youth.

The Grand Opera House, circa 1907. The opera house opened in 1875 on Pennsylvania Street north of Market, and the caption on this photo describes it as the "original of the Pennsylvania Street amusement center." One history claims that it was the first American theater to be electrically lit. In 1910 it was renamed B. F. Keith's.

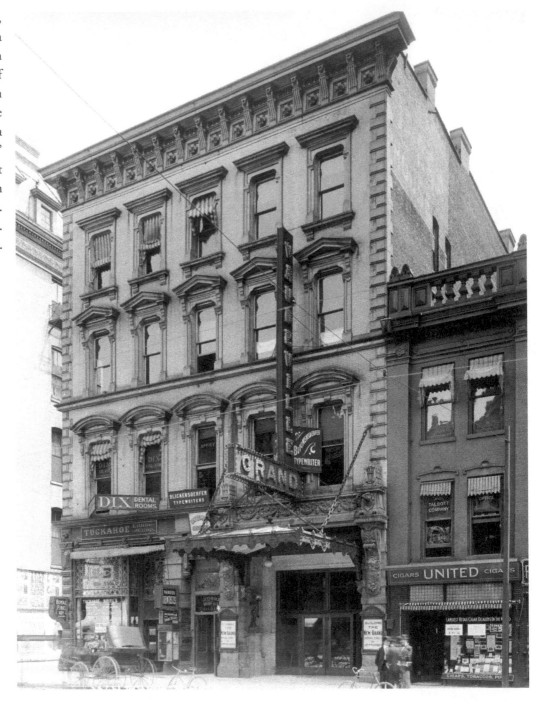

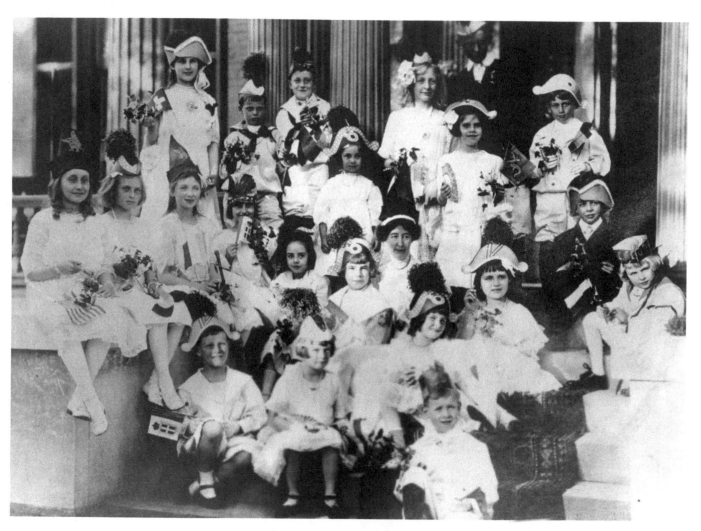

A children's dance class, circa 1907. The students appear ready to give a performance.

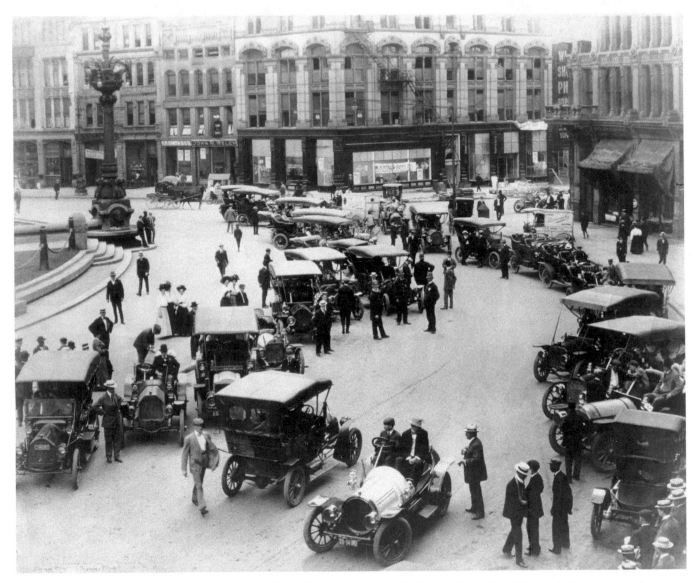

The west side of Monument Circle, 1908. Automobiles began appearing in Indianapolis in the 1890s, and they were starting to dominate the streets by the time this photograph was taken. In Indianapolis author Booth Tarkington's Pulitzer Prize-winning novel *The Magnificent Ambersons*, character Eugene Morgan predicts the effect: "This town's already spreading; bicycles and trolleys have been doing their share, but the automobile is going to carry city streets clear out to the county line."

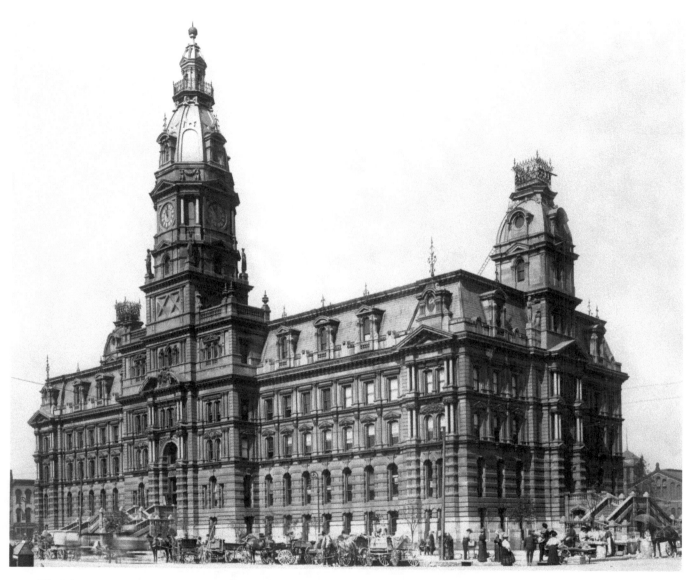

The Marion County courthouse, 1908. This structure, located on the north side of Washington Street between Delaware and Alabama streets, served as Marion County's second seat of government. Designed by Isaac M. Hodgson and dedicated in 1876, it epitomized Second Empire–style architecture. By the 1950s it had fallen into disrepair, and because both it and the city hall had run out of space, community leaders decided to build a new structure that would combine the offices of both the city and the county. After the new city-county building opened in 1962, wrecking crews demolished the courthouse. Over the years Indianapolis has suffered many architectural losses, but the courthouse is one of the greatest.

A young boy sells fruit at the Indianapolis city market, 1908.

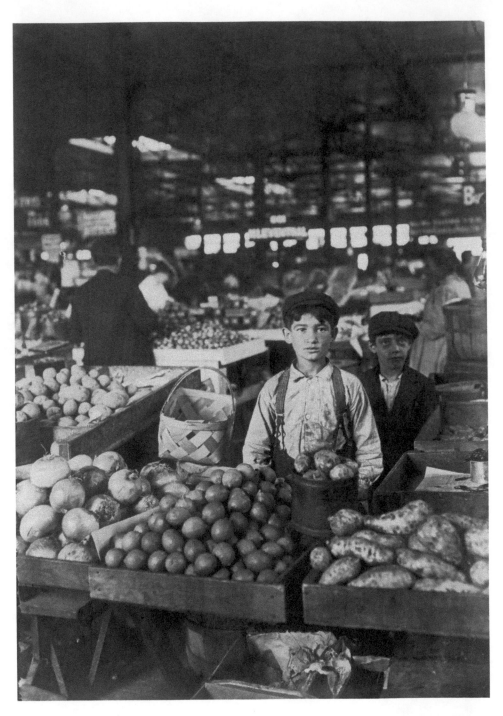

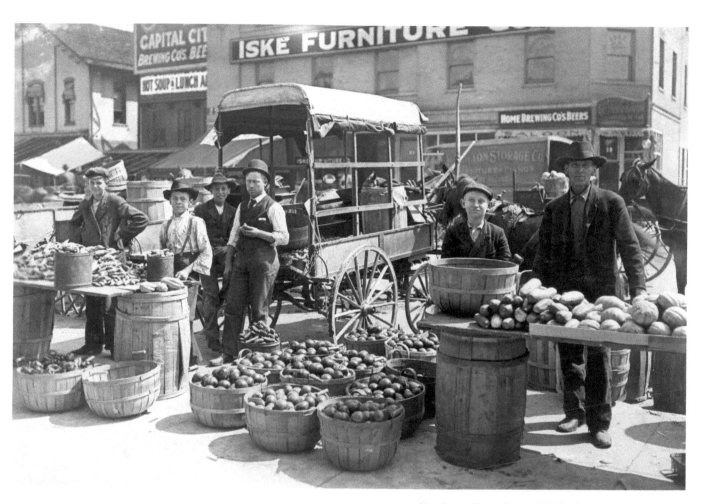

Vendors sell produce outside the city market, 1908.

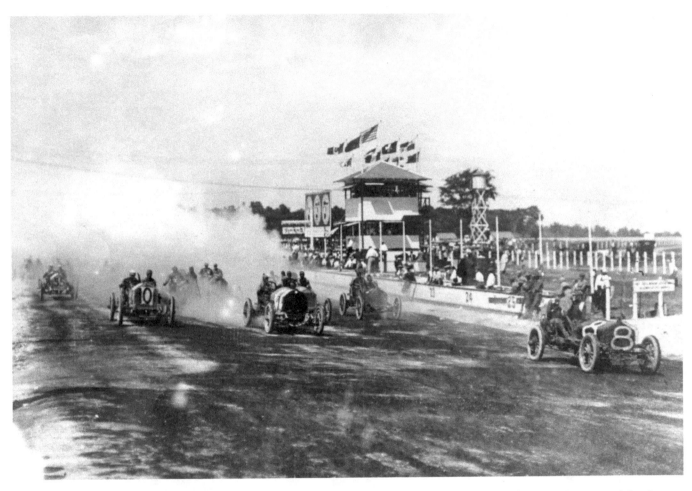

The start of an automobile race at the Indianapolis Motor Speedway, 1909. The speedway was built as a testing ground for the numerous Indianapolis-based auto manufacturers, and the first motorcycle and auto races were held there in August 1909. The track of crushed rock and tar was rough and resulted in many accidents, so in September the owners paved it with 3,200,000 bricks. The track hosted the first 500-mile race on May 30, 1911.

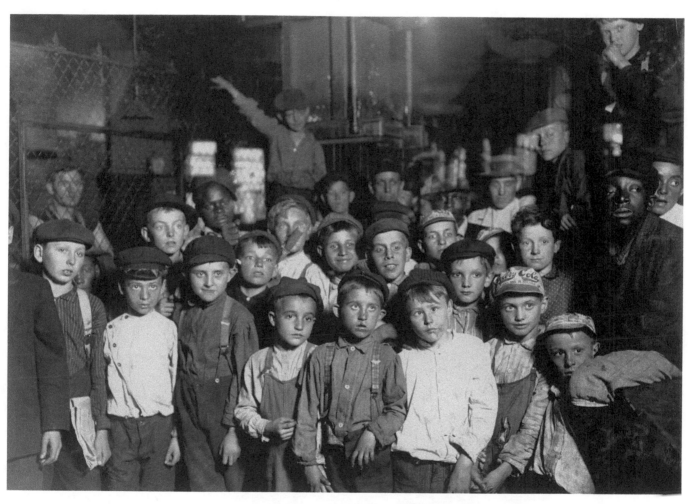

Indianapolis newsboys wait for the baseball edition in the offices of a local paper, 1908.

Eighth-grade graduates of School No. 10, 1910. The school was located on the southeast corner of Thirteenth Street and Carrollton Avenue. Today the entire intersection is gone, paved over by ramps connecting I-65 and I-70.

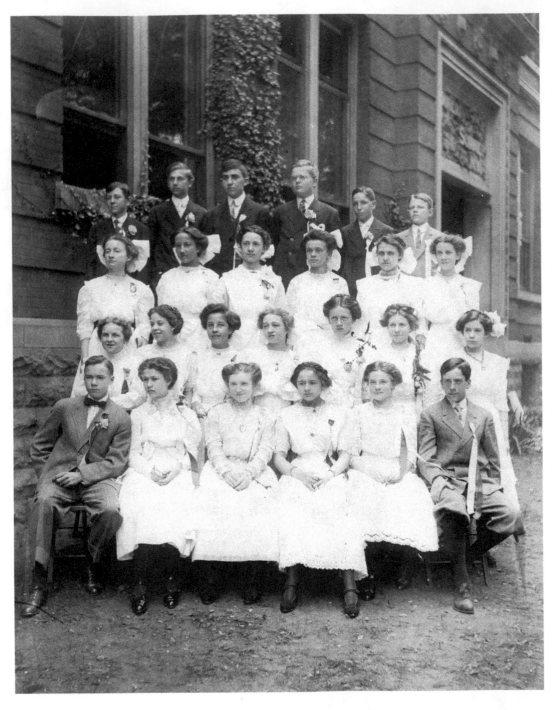

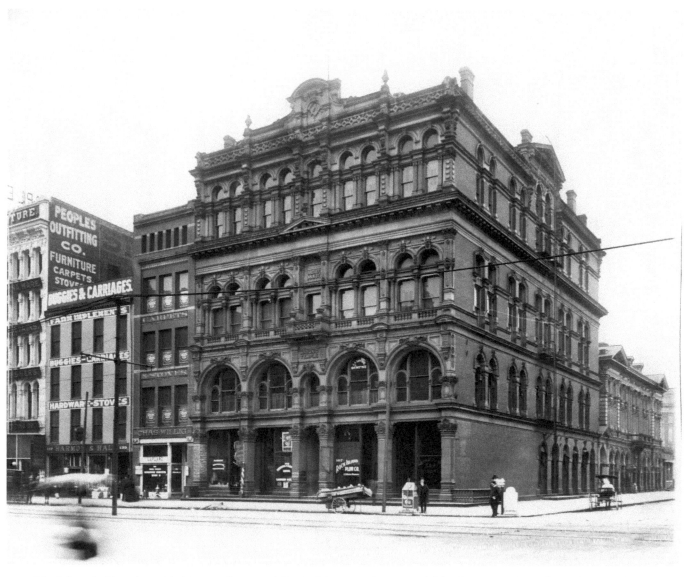

The Masonic Temple at Washington Street and Capitol Avenue, circa 1910. This photo was taken about the time the Masons moved to a new lodge at Illinois and North streets.

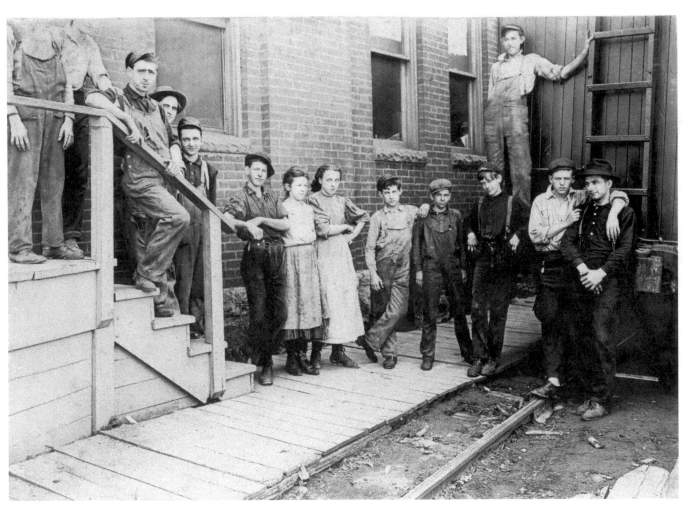

Noon hour at an Indianapolis cannery, 1908.

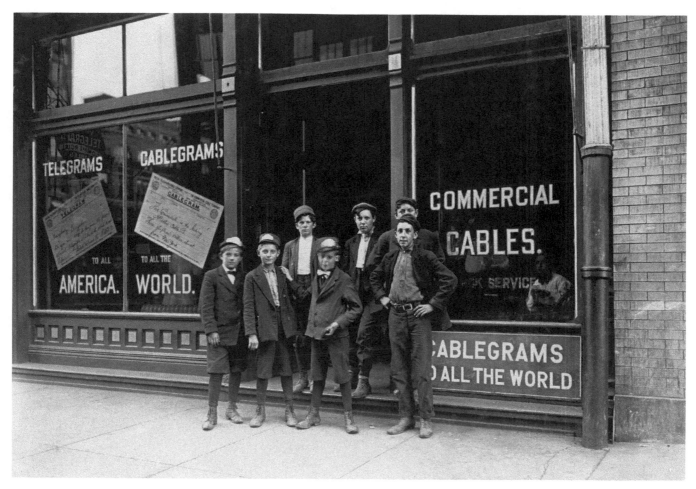

American District Telegraph Company messengers outside the company office, 1908. The office was located on Monument Circle.

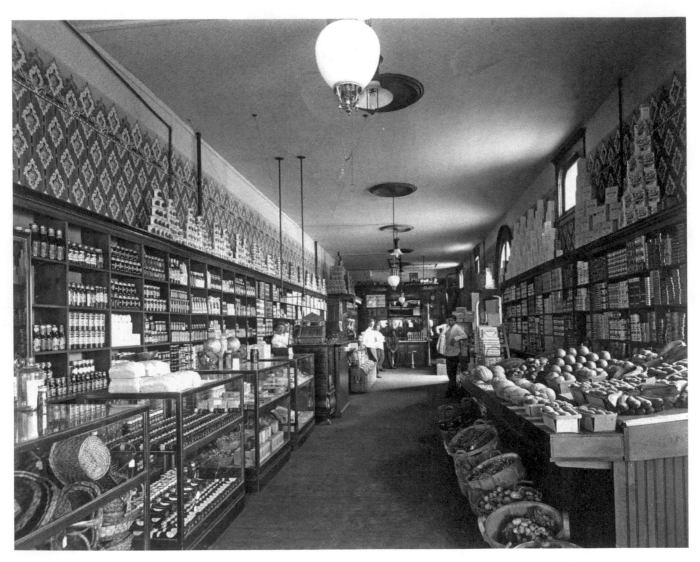

The Moore Grocery Company, circa 1910. The grocery was located on the east side of Illinois Street near Ohio Street.

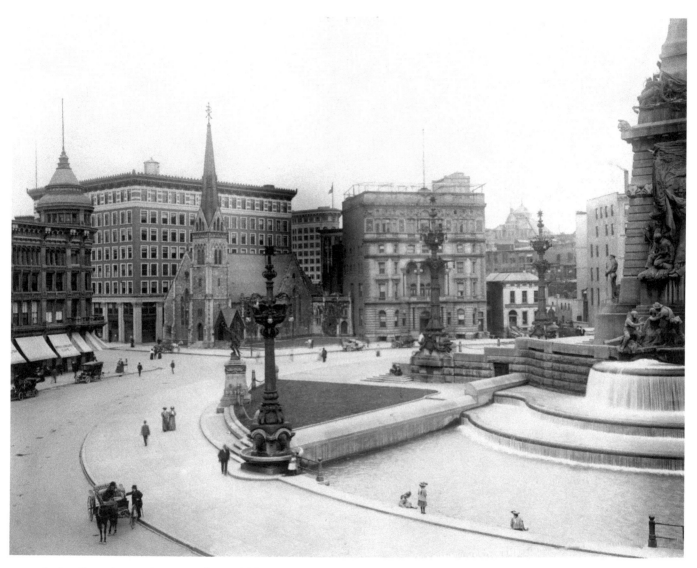

A view from the northwest quadrant of Monument Circle, circa 1910s. The buildings shown here include (from the left) the English Hotel, the Board of Trade building, Christ Church, the old Columbia Club, and the Indianapolis Water Company office (located in the house). Christ Church, completed in 1859, is the only one of these structures still standing.

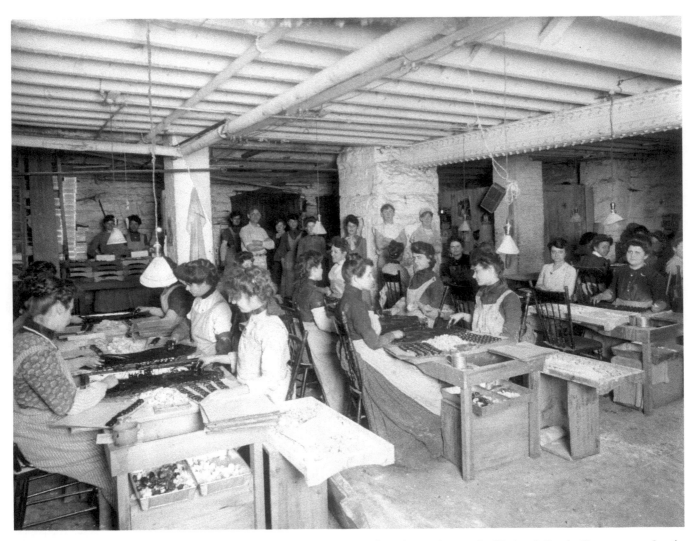

Workers at an Indianapolis candy factory, circa 1910. This photo may have been taken at the National Candy Company on South Meridian Street.

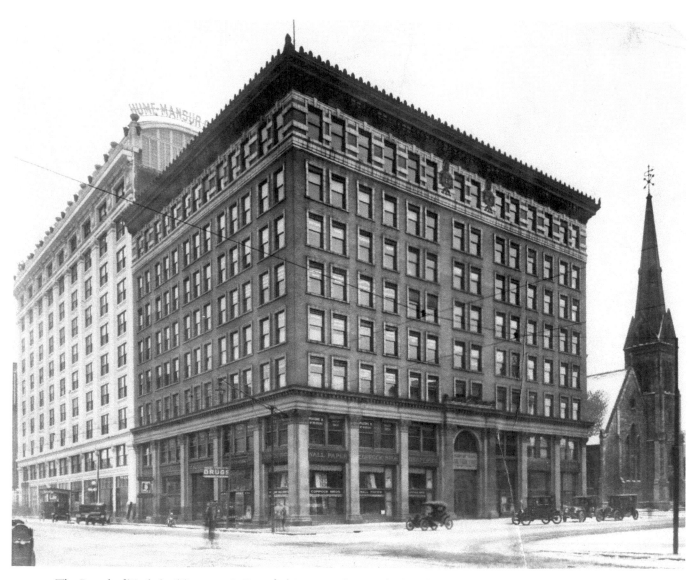

The Board of Trade building, 1912. Founded in 1853, the Board of Trade was an early promoter of Indianapolis's business community. In later years it helped establish uniformity in commercial practices, advance business ethics, and settle trade disputes. This building on the southeast corner of Meridian and Ohio streets served as the board's home from 1907 until it ceased operations in 1977. The Chase Tower, Indianapolis's tallest skyscraper, now stands on the site.

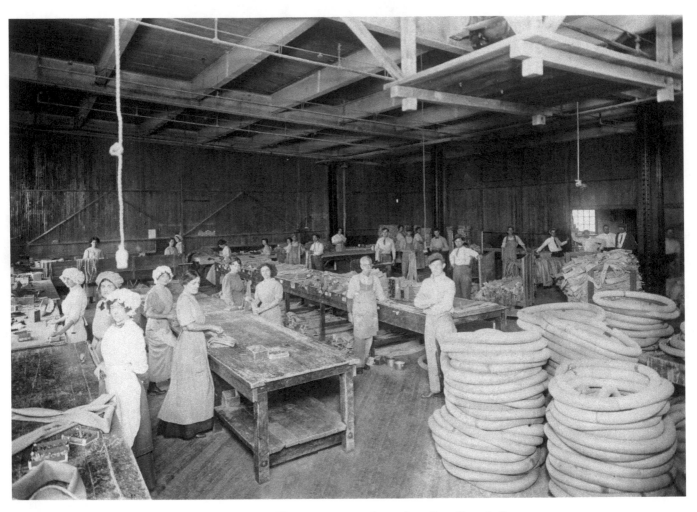

Workers at the G and J Tire Company, circa 1910. The company was located on East Georgia Street.

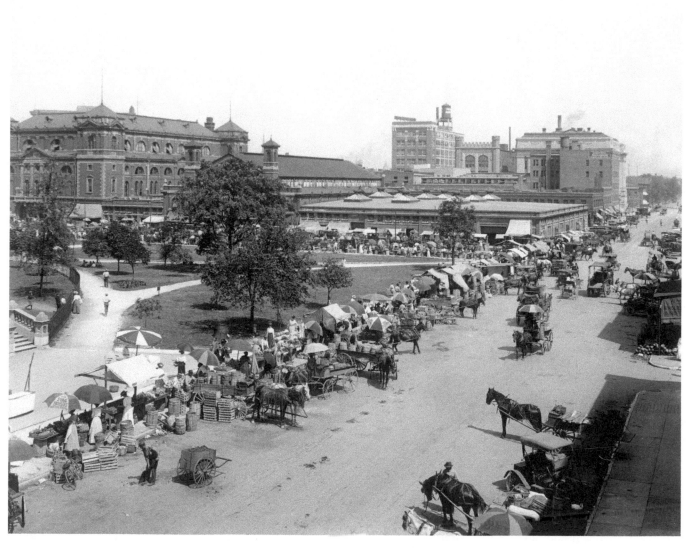

Vendors sell their wares along Alabama and Market streets, circa 1912. For decades farmers peddled meats and produce on these streets near the city market (which is partially seen in the background, obscured by the tree).

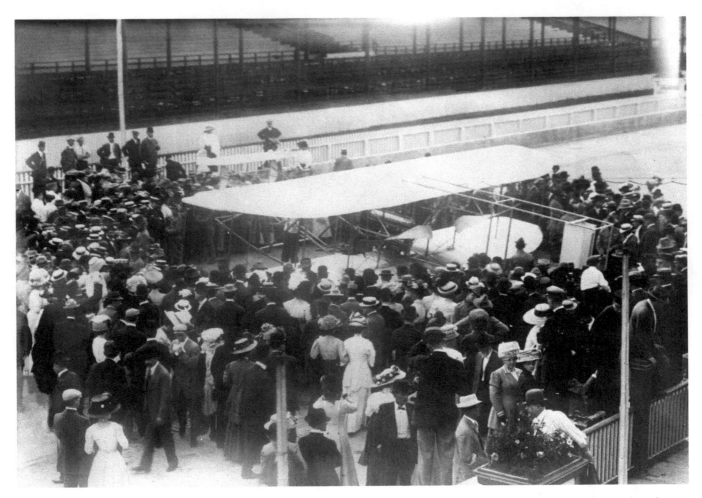

Crowds gather around an airplane at the Indianapolis Motor Speedway, circa 1910s. This photograph may have been taken during a June 1910 aviation meet featuring the Wright brothers and six of their planes. The Speedway played an important role in the city's early aviation history, hosting many airplane races, serving as home to the Aero Club of Indianapolis, and housing hangars during World War I.

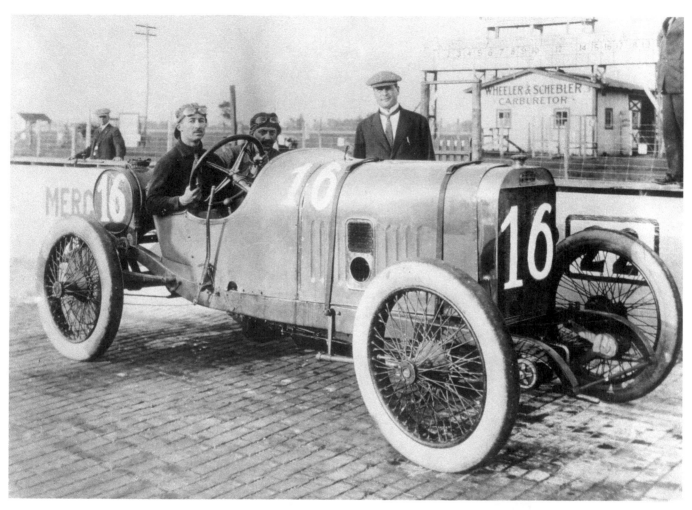

Jules Goux poses in his No. 16 Puegeot after victory at the 1913 Indianapolis 500. Goux, a Frenchman, was the first European to win the famed race.

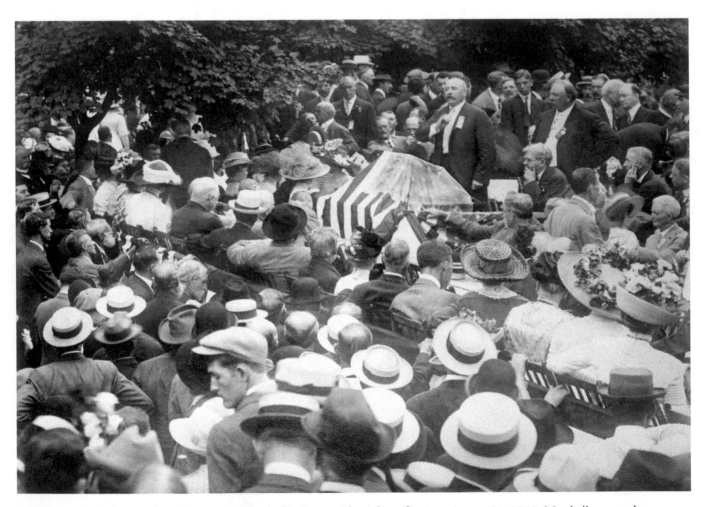

Judge Alton B. Parker speaks at Thomas R. Marshall's vice-presidential notification, August 20, 1912. Marshall ran on the Democratic ticket with Woodrow Wilson and was elected vice-president that fall. The notification ceremony took place at Meridian and Vermont streets. Thousands turned out to celebrate, but the festivities were dampened when a viewing stand collapsed during Parker's speech, injuring dozens.

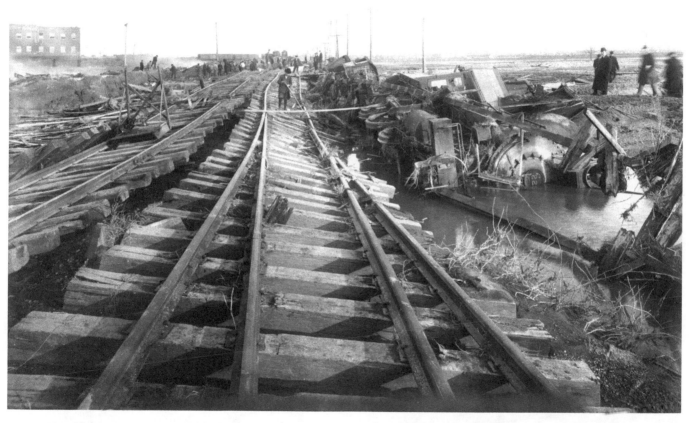

Flood damage to trains and rails, 1913. In March 1913, heavy rains fell on Indiana and other parts of the Midwest, causing extensive flooding. In Indianapolis the White River crested at an estimated 19.5 feet above flood level, bursting levees and sending water rushing through the city, especially the western sections. The flood was the worst in the city's history, causing about two dozen deaths and leaving some 7,000 families homeless.

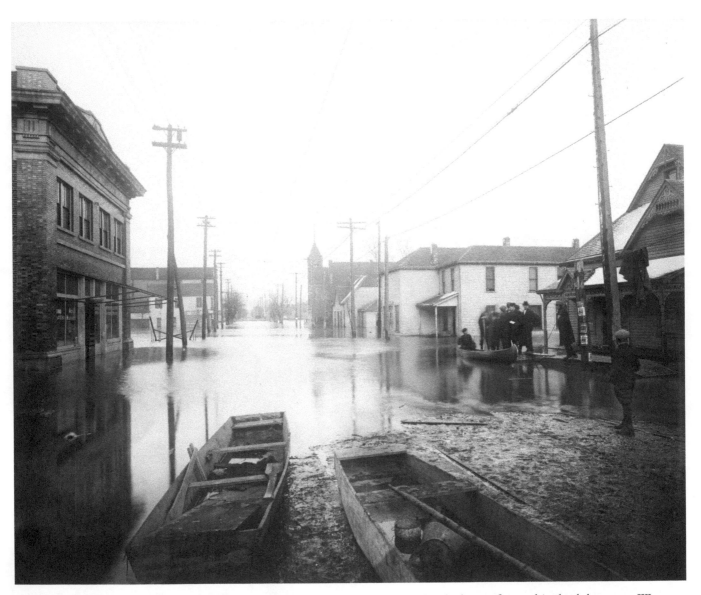

Morris Street during the 1913 flood. At the time of the flood, Morris Street was in the heart of an early suburb known as West Indianapolis (bounded by today's Washington Street, White River Parkway, Raymond Street, and Belmont Avenue). The area was especially hard hit by the deluge.

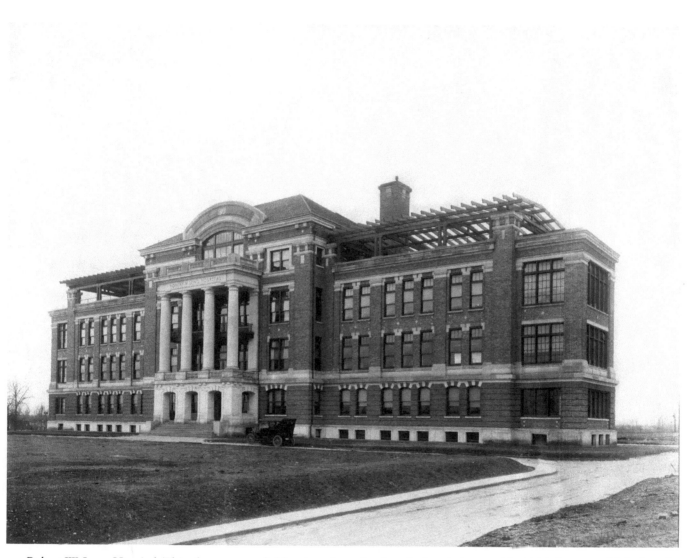

Robert W. Long Hospital. This photo was probably taken about the time the hospital opened in 1914. It was established as the teaching center for the Indiana University School of Medicine and still stands on West Michigan Street.

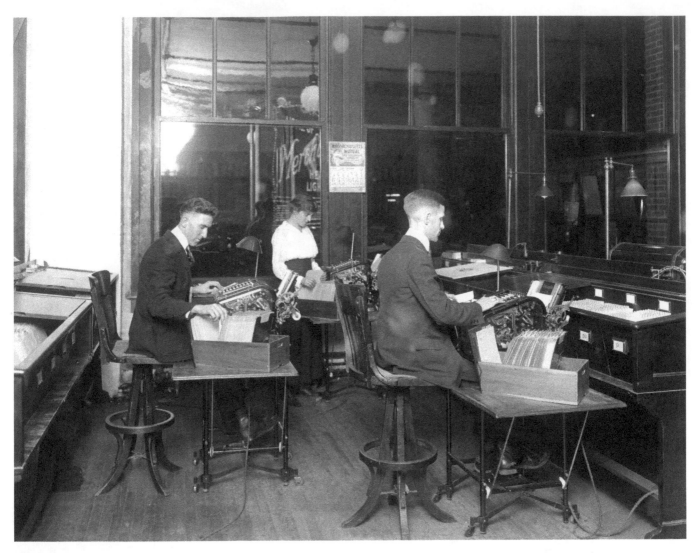

Clerks at L. S. Ayres and Company, 1916. In 1872 Lyman S. Ayres bought a controlling interest in the Trade Palace, an Indianapolis dry-goods store. Two years later he moved to the city from New York State and changed the name of the establishment to L. S. Ayres and Company. As Indianapolis grew, business at Ayres prospered, and in 1905 Lyman Ayres's son Frederic moved operations to a new eight-story building on the southwest corner of Washington and Meridian streets. It was the city's first modern department store. Over the years Ayres became the city's premier retail establishment and a beloved fixture of Indianapolis life.

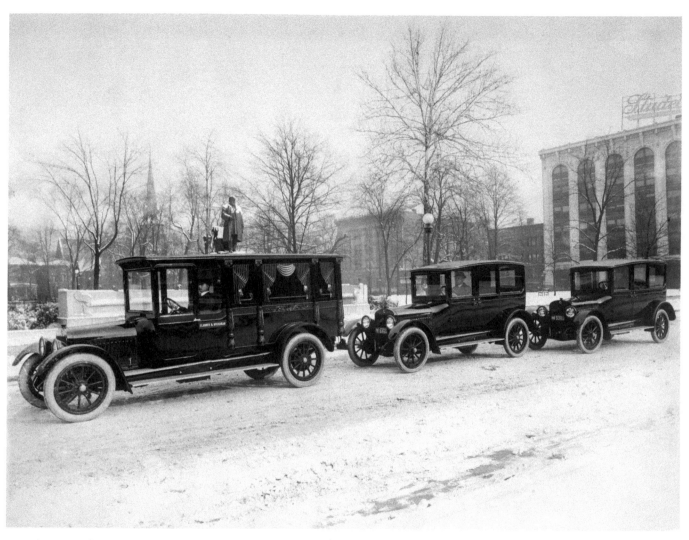

A Flanner and Buchanan hearse leads a funeral procession along the south side of University Park, 1914. Flanner and Buchanan, one of the city's leading funeral homes, dates to 1881, when Frank Flanner opened a mortuary on Illinois Street. The business adopted its current name six years later when Charles Buchanan, Flanner's brother-in-law, joined the firm. Today the Buchanan family continues to operate the business, which includes several facilities in Indianapolis and its suburbs.

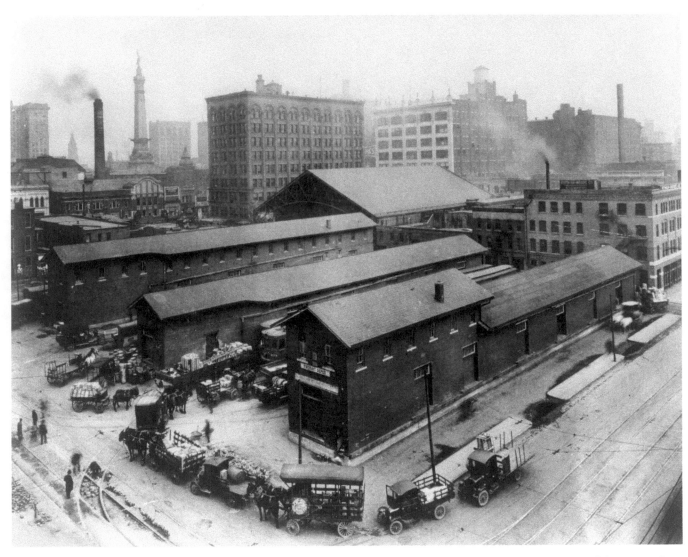

The Indianapolis Traction Terminal's freight houses, circa 1916. These buildings stood on the northwest section of the terminal complex, near the corner of Capitol Avenue and Ohio Street. By 1916 an average of 71 cars of freight left the terminal each day.

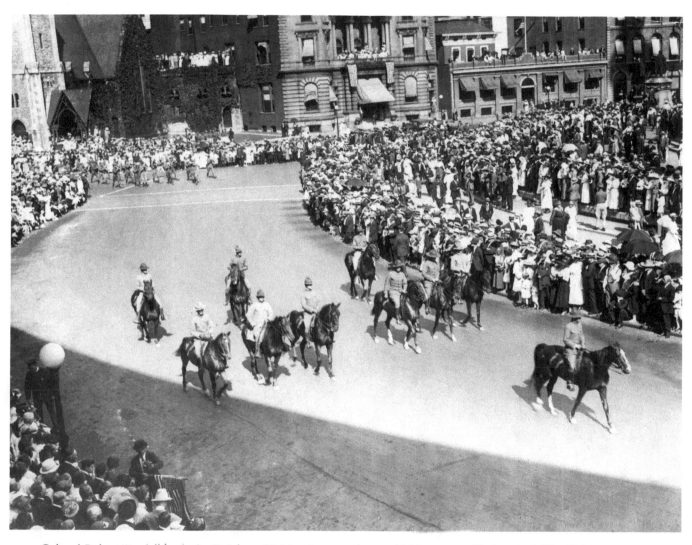

Colonel Robert Tyndall leads the Rainbow Division in a parade around Monument Circle, 1917. The division was preparing to depart for World War I. In 1941, Tyndall retired as a major general after 44 years in the army. He then served as Indianapolis mayor from 1943 to 1947.

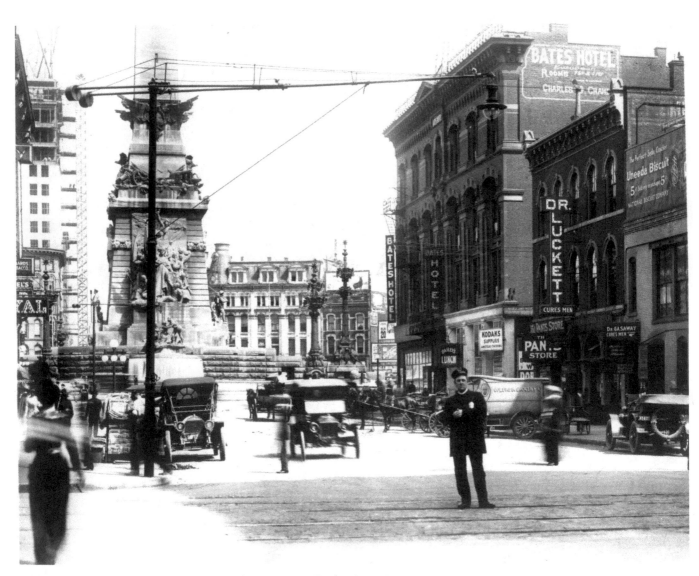

A view of Market Street, looking east toward Monument Circle, circa 1918.

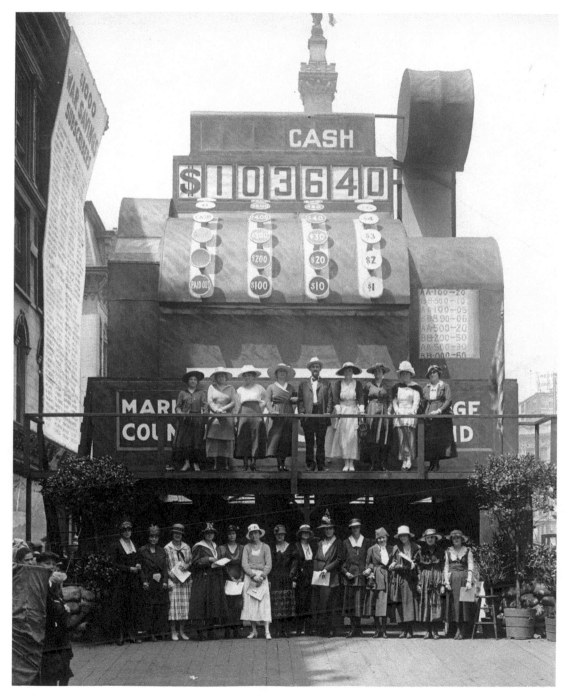

A giant cash register on Monument Circle, 1918. Organizers used this gimmick to track donations to the Marion County War Savings Subscribers Pledge Fund during World War I.

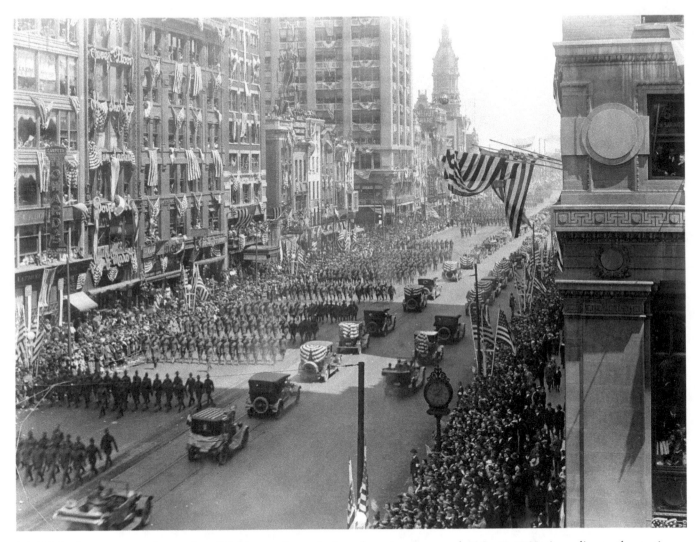

World War I veterans march east along Washington Street during a homecoming parade, May 7, 1919. According to the caption on the photo, the automobiles were carrying wounded soldiers.

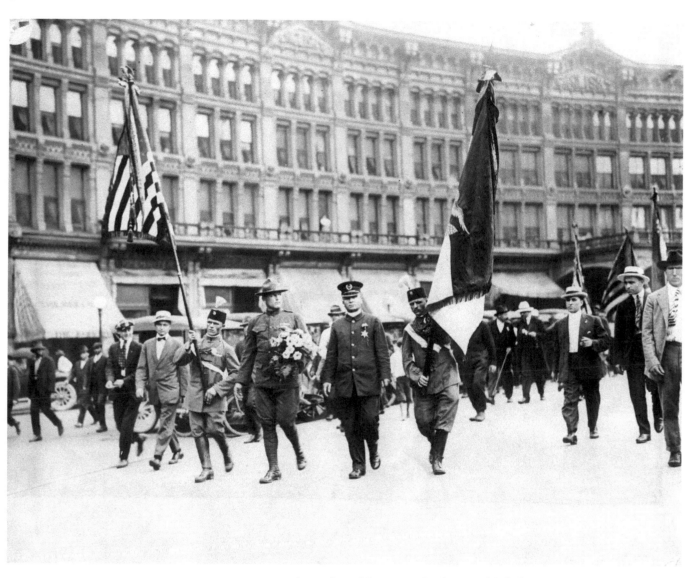

A parade on Monument Circle, most likely honoring World War I soldiers.

Young women package vaccine at Eli Lilly and Company, 1919. Colonel Eli Lilly founded the pharmaceutical company in a small building on Pearl Street in 1876. Still headquartered in its hometown of Indianapolis, Lilly has grown into an international corporation with more than 42,000 employees worldwide.

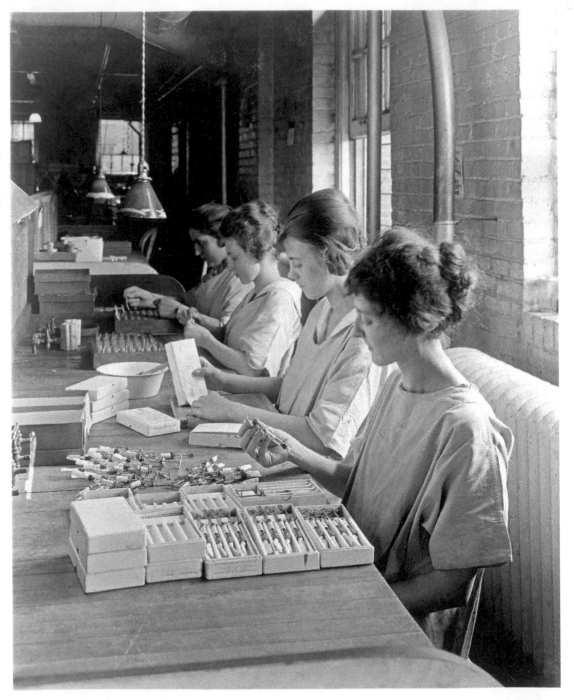

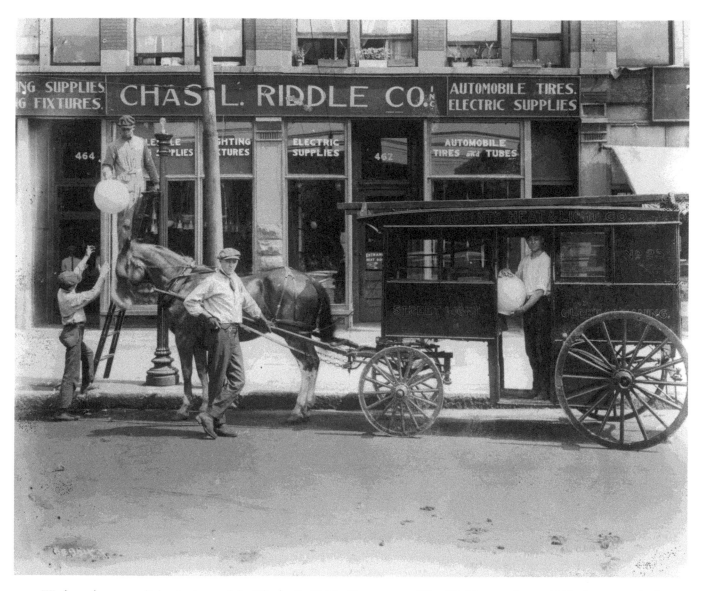

Workers clean streetlights in front of the Charles L. Riddle Company on West Washington Street, 1919. A note on the image indicates that "this simple job needed three men, a boy, a horse, and a wagon."

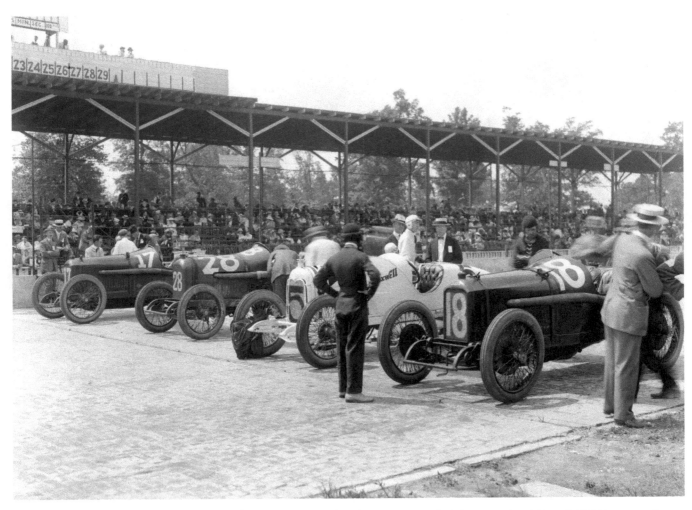

The front-row starters at the 1919 Indianapolis 500. The speedway's owners cancelled the event in 1917 and 1918 because of World War I, so fans were especially eager to see the start of the race that year.

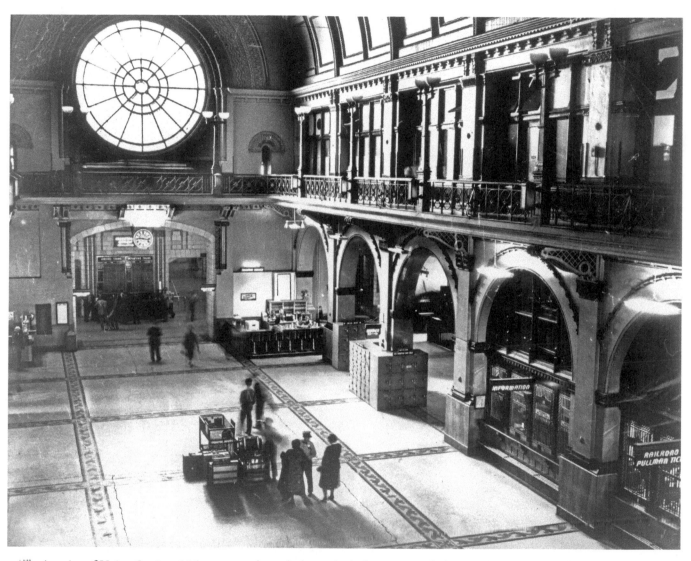

The interior of Union Station. Light streams through the station's elegant stained-glass windows as porters load bags and prepare to guide passengers through the arched doorway to the elevated tracks.

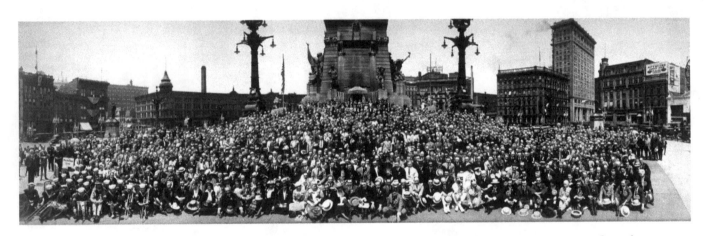

The Associated Advertising Clubs of the World on the south steps of the Soldiers and Sailors Monument, 1920. Over the years many groups have gathered for photos at this spot.

Hard Hearts, Hard Times

(1920–1939)

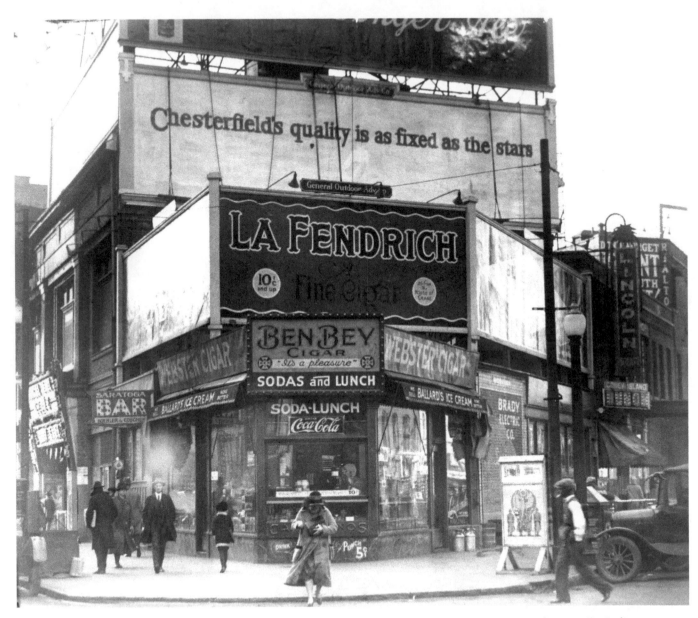

The intersection of Illinois Street and Kentucky Avenue, circa 1920s. The Fendrich Cigar Company of Evansville, Indiana, manufactured the cigar prominently advertised on the billboard.

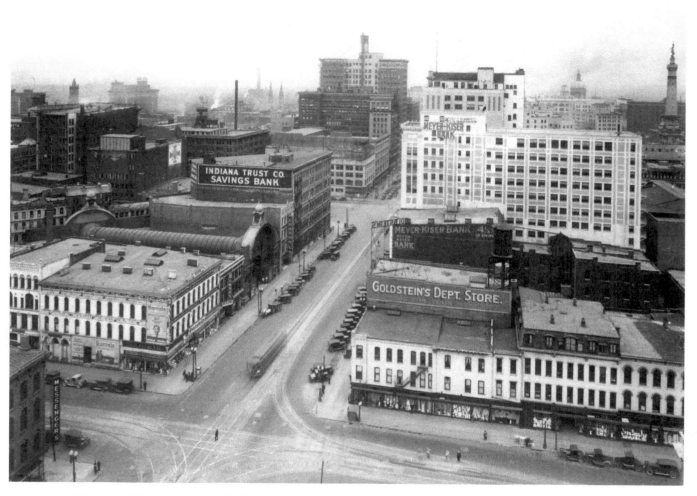

An aerial view of Washington Street looking west, circa 1920s. The barrel-roofed building is the Pembroke Arcade, which ran between Washington Street and Virginia Avenue and housed small shops. It opened in the mid-1890s and was razed in 1943.

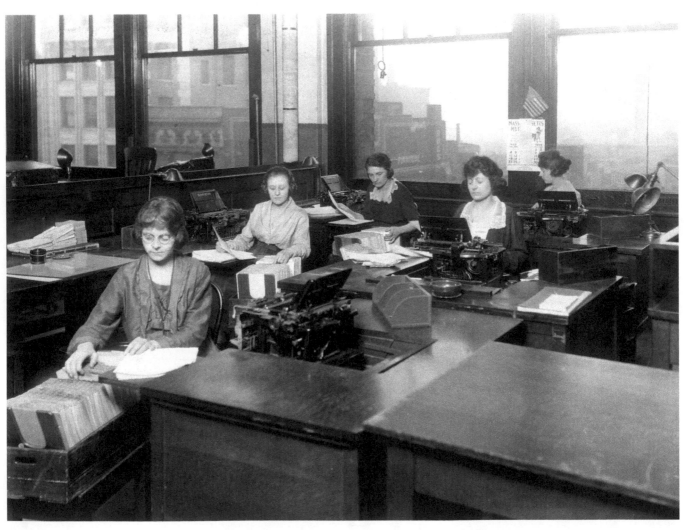

Workers at L. S. Ayres and Company, circa 1920s. The windows in the back offer a view of Washington Street.

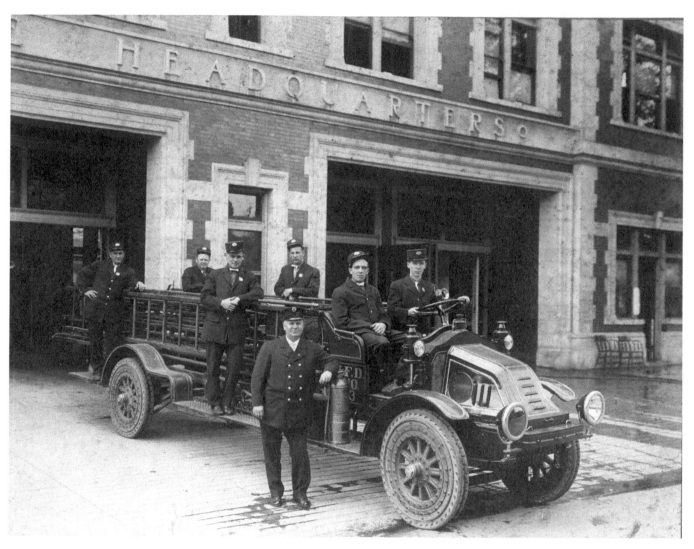

Indianapolis firefighters proudly show off their engine, circa 1920s. This photo was taken outside the fire headquarters, which was located on the southeast corner of New York and Alabama streets.

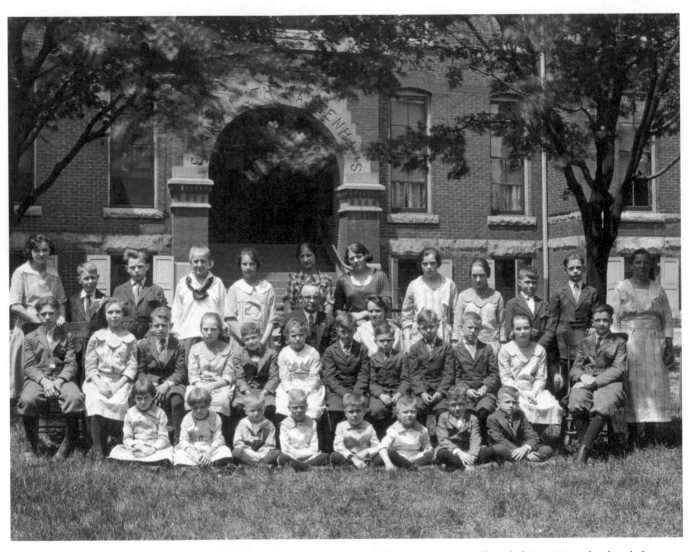

Young wards of the Evangelical Lutheran Orphans' Home, circa 1920s. The orphanage was founded in 1883 and a decade later moved into a new east-side home at Washington and LaSalle streets. In 1956, it relocated again to Sixteenth Street and Ritter Avenue. Its mission has evolved over the years; today it is known as Lutherwood and serves as a residential treatment center for children who are recovering from the effects of abuse, neglect, or abandonment.

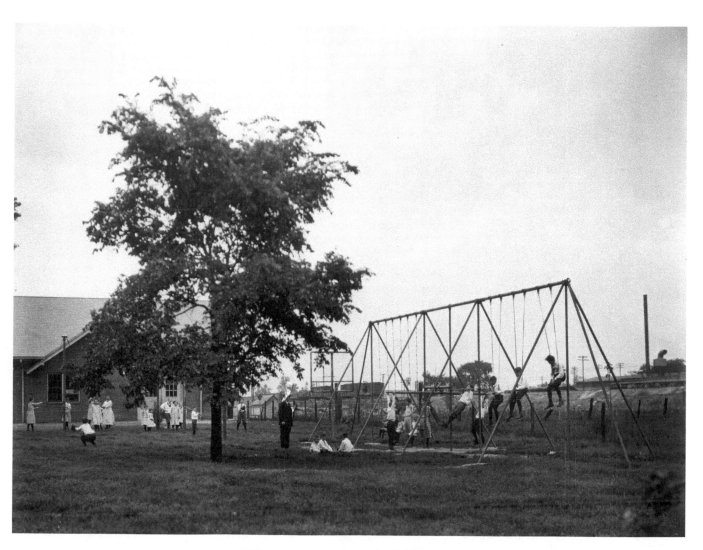

Children play on the grounds of the Evangelical Lutheran Orphans' Home, circa 1920s.

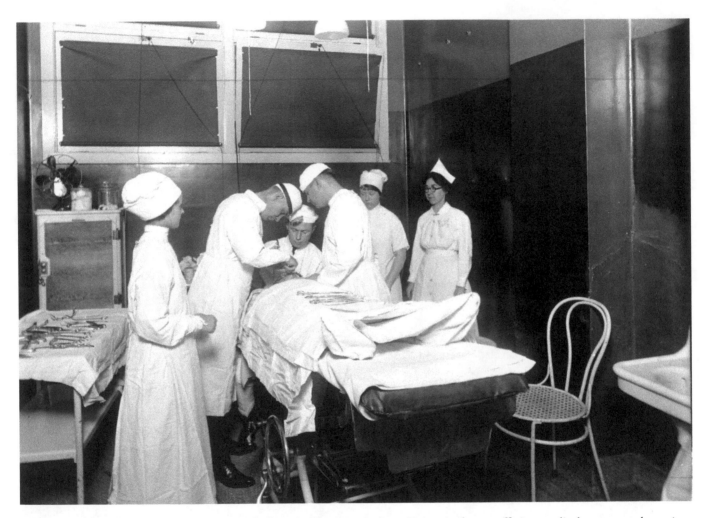

An operation at the Indiana University School of Medicine, 1923. Indiana University began offering medical courses at the main Bloomington campus in 1903, with clinical training conducted in Indianapolis. Five years later all medical schools in the state merged with the Indiana University program to form the IU School of Medicine. The school taught courses and conducted research at Indianapolis-area hospitals, including City Hospital.

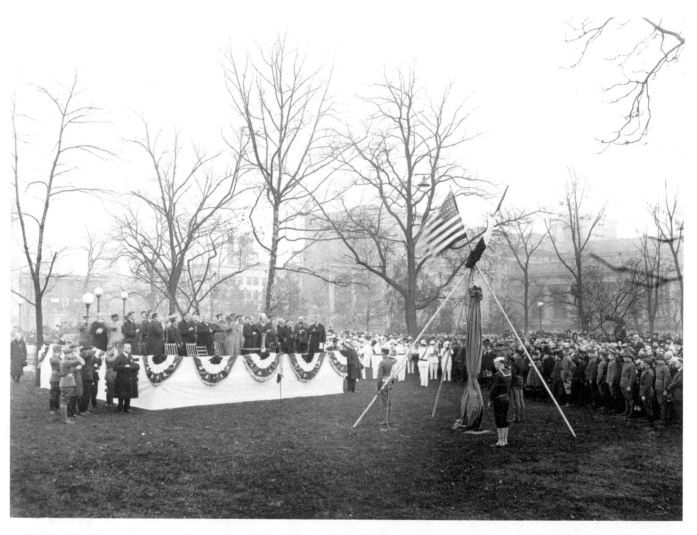

Marshal Foch lays a ceremonial cornerstone for the Indiana World War Memorial during his visit to Indianapolis, November 4, 1921. After World War I the state of Indiana began planning a memorial and plaza to honor veterans of the Great War. Design work began in 1921, and when Foch was in the city he dedicated the stone, which was salvaged from a bridge that spanned the Marne River. The dedication was merely symbolic. Actual construction of the memorial didn't begin until 1927, and at that time General John J. Pershing, leader of the American Expeditionary Force in World War I, laid the actual cornerstone.

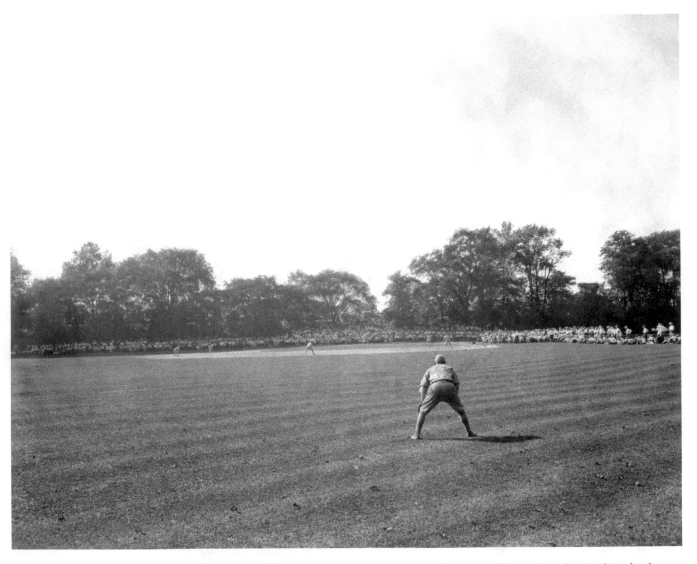

A baseball game in Brookside Park, circa 1920s. This east-side greenspace was one of Indianapolis's earliest; the city bought the land in the 1890s.

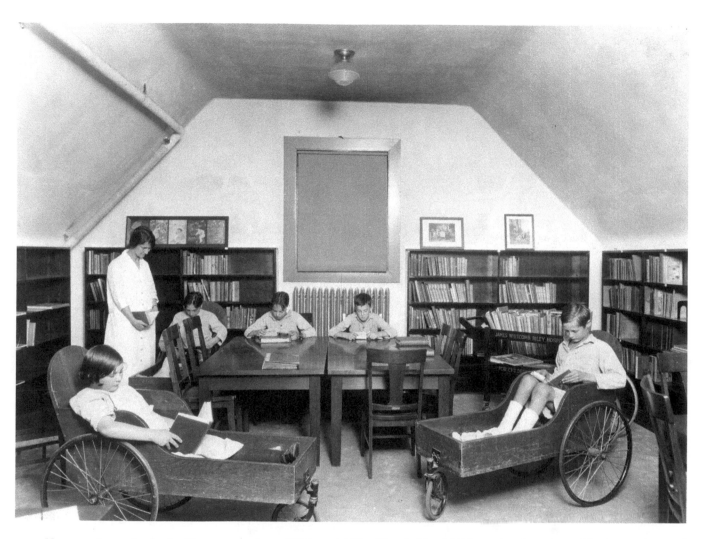

Young patients relax in the library at the James Whitcomb Riley Hospital for Children, circa late 1920s. The hospital opened in fall 1924 as a tribute to Riley, the beloved Hoosier poet. It continues to serve Indiana children today and is renowned for its quality care.

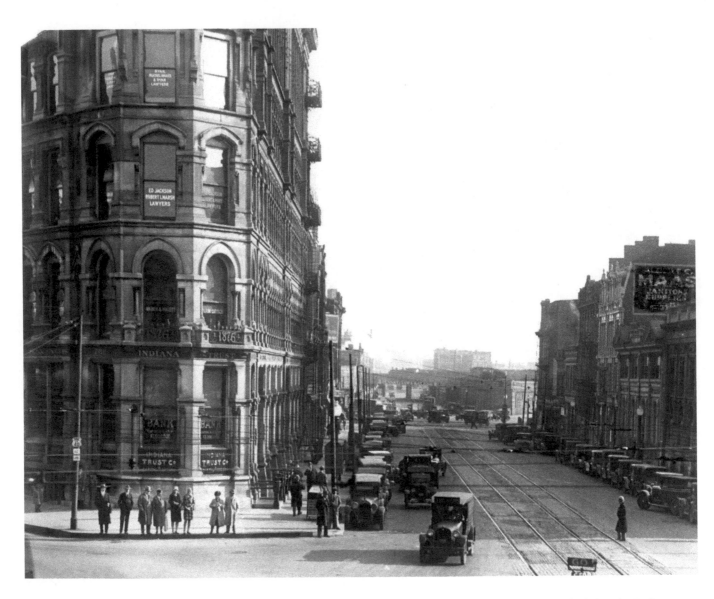

Virginia Avenue looking southeast from Washington Street, circa 1920s. The ornate flatiron building on the left is the Indiana Trust Company building (also known as the Vance block), long ago demolished.

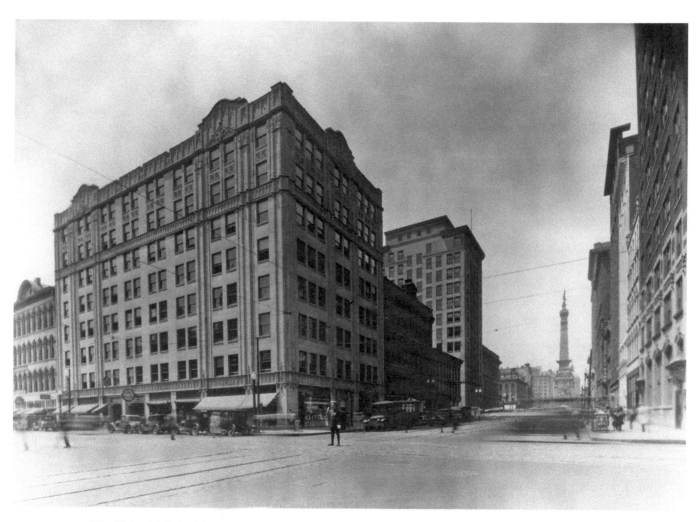

The Union Title building, 1928. This structure still stands on the southwest corner of Market and Delaware streets.

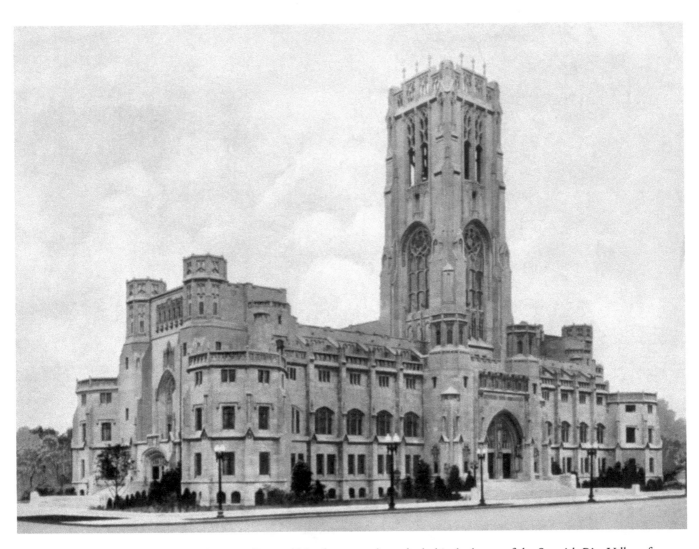

The Scottish Rite Cathedral. Located at Meridian and North streets, the cathedral is the home of the Scottish Rite Valley of Indiana, a Masonic order. Member George F. Schreiber designed it and laid it out in multiples of 33 feet, representing the number of years in Christ's life. The tower holds 54 bells, one of the largest carillons in the world. The cathedral opened in 1929.

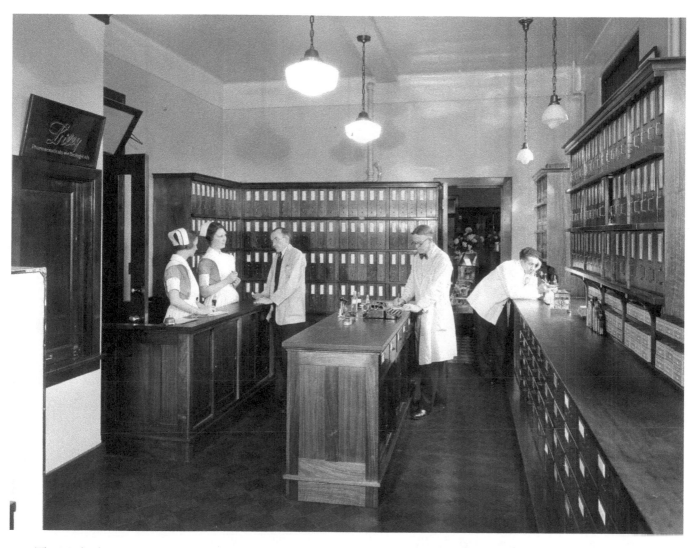

The Methodist Hospital pharmacy, 1931. Methodist Hospital opened in April 1908 at its current location on Capitol Avenue north of Sixteenth Street. Over the years it has been on the leading edge of medical research—working with Indianapolis pharmaceutical firm Eli Lilly and Company in the 1920s to test the use of insulin, for example, and in 1982 becoming the first private hospital in the world to perform a heart transplant. Today the hospital is part of Clarian Health Partners and is noted for its programs in cancer treatment; digestive disorders; ear, nose, and throat conditions; kidney disease; orthopedics; and urology.

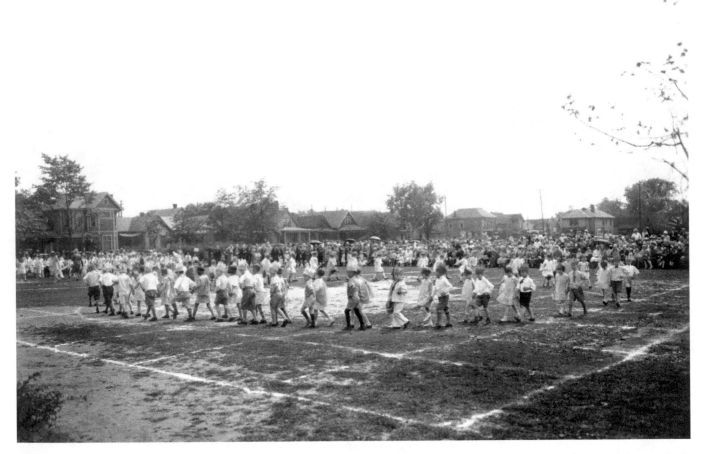

Children parade in a large circle at Finch Park on the city's southeast side, 1929. Upon her death in 1923, Alice Finch bequeathed $10,000 to Indianapolis's parks department, and in honor of her and her family the city opened Finch Park at State and Spann avenues. In the late 1980s, Indianapolis Public Schools swapped land with the parks department and built a new School No. 39 on the site of the old Finch Park. The parks department then opened a new Finch Park two blocks south on State Avenue.

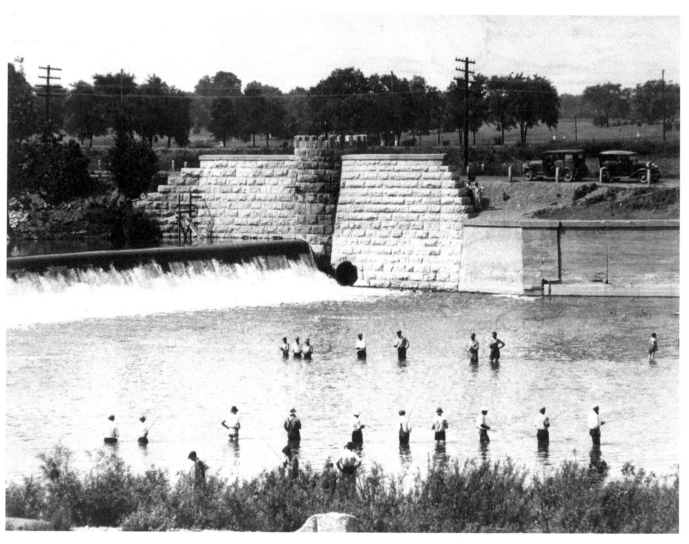

The Emrichsville dam, 1933. The dam is located on the White River near Sixteenth Street. Nearby stood the Emrichsville bridge, which featured a stone archway and tower as well as ornate carvings.

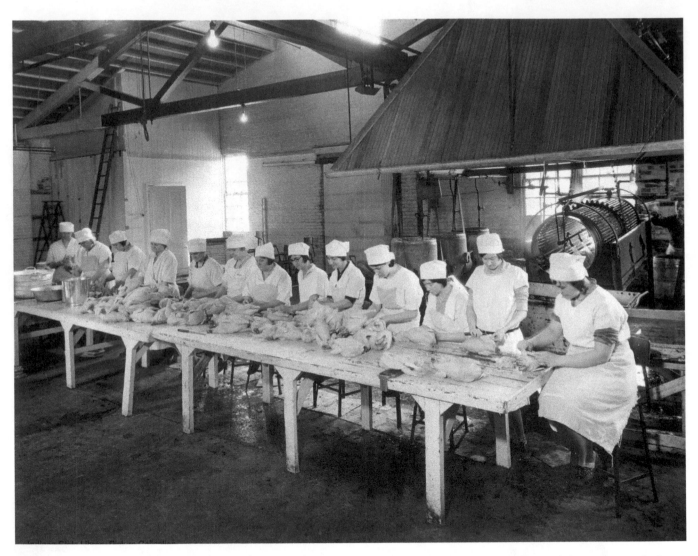

Workers at the Columbia Conserve Company, circa 1930s. Columbia was a canning factory on Indianapolis's southeast side. In 1917, under the guidance of its president, William Powers Hapgood, it underwent an experiment in worker democracy. Hapgood transferred ownership to the employees and gave them the opportunity to make management decisions via a workers' council. They also shared in the profits. The company received international attention for its efforts, but it went bankrupt in the early 1940s and was dissolved.

A view of South Meridian Street from the Soldiers and Sailors Monument, 1933.

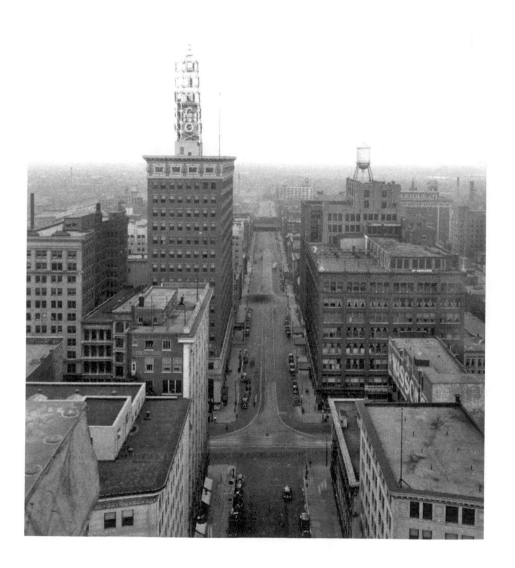

Members of Trinity Evangelical Lutheran Church celebrate 25 years of service by Reverend J. W. Matthias, September 18, 1935. The celebratory dinner took place at the church's school building, located at Market and Arsenal streets on the city's east side. The church's sanctuary was located at Ohio and East streets.

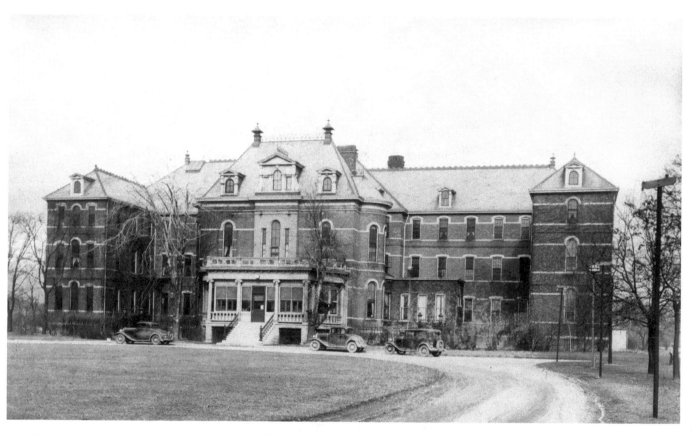

The Indiana Women's Prison, 1935. The prison opened on the east side of Indianapolis in October 1873. Some histories report that it was the first prison built in the United States to house female criminals.

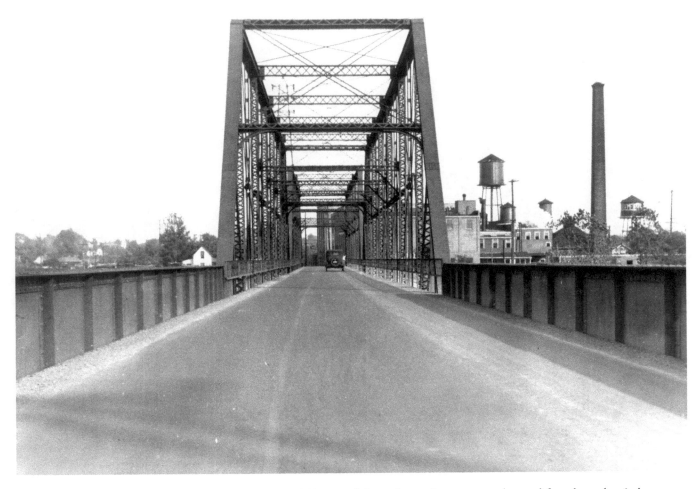

The Raymond Street bridge over the White River, 1936. Raymond Street is a major east-west thoroughfare along the city's south side.

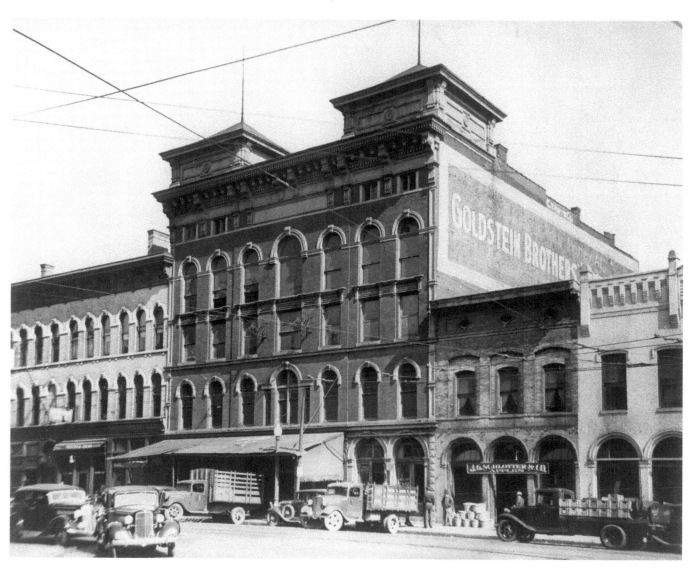

Germania Hall around the time of its demolition in early 1936. The hall was located on South Delaware Street, between Washington and Maryland streets. It was part of Commission Row, an area along Delaware, Alabama, and Maryland streets known for its produce firms. Germania Hall hosted many social events for Indianapolis's sizable German community, including New Year's Eve dances, card games, and German operettas. It had a dining room and meeting rooms and was a convenient gathering place for singing societies and groups such as the Butcher Ladies' Union.

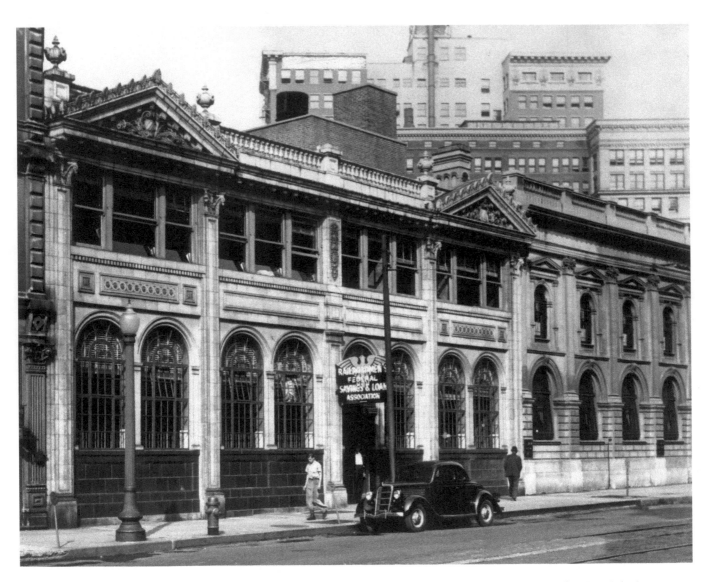

The Railroadmen's Federal Savings and Loan Association building, 1937. The savings and loan was located on Virginia Avenue, near its intersection with Washington and Pennsylvania streets.

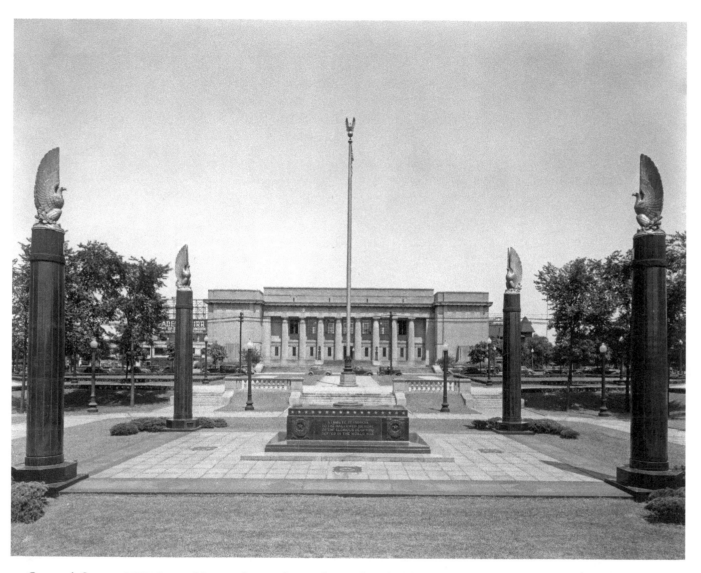

Cenotaph Square, 1937. Located in a sunken garden on the north end of the Indiana World War Memorial Plaza, the cenotaph serves as a tribute to Indiana's war dead. Across St. Clair Street stands the Indianapolis Public Library (today known as the Indianapolis-Marion County Public Library), designed by Philadelphia architect Paul Cret and opened in 1917.

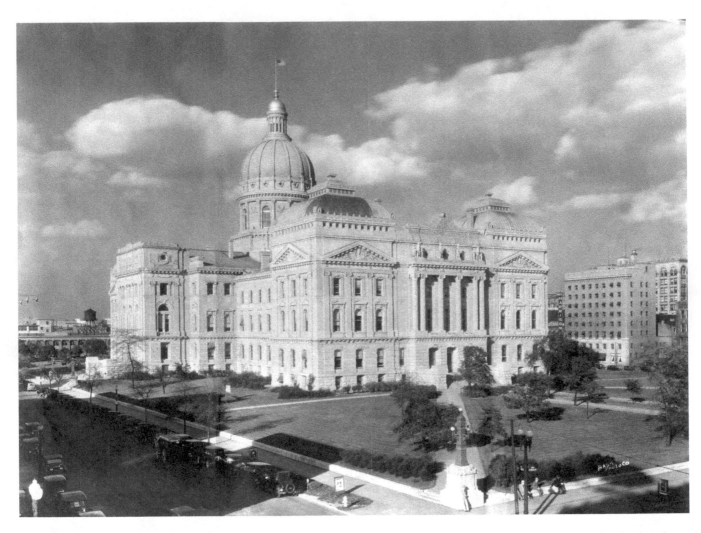

The Indiana State Capitol, circa 1930s. Indianapolis officially became Indiana's capital in 1825. This building is the third in the city to serve as the seat of government. It was completed in 1888 and was restored to much of its original splendor in time for its centennial.

THE CITY AT A CROSSROADS

(1940–1960s)

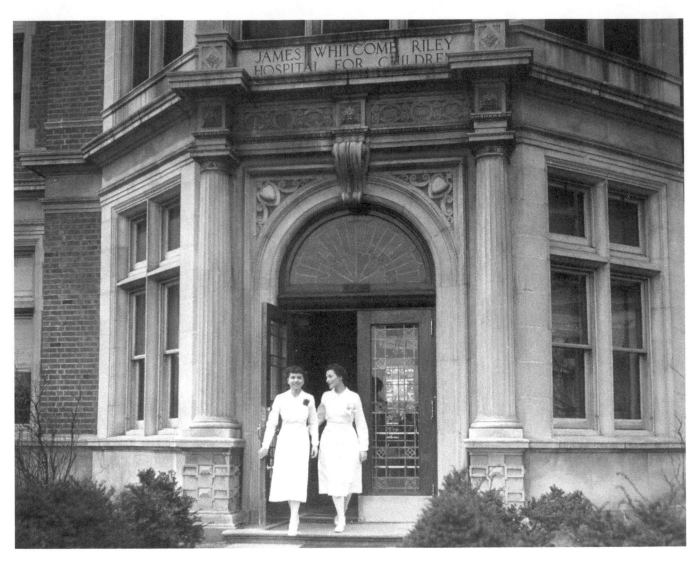

Nurses leave the James Whitcomb Riley Hospital for Children, circa 1940s. Many of the hospital's staff members received training at the nearby Indiana University School of Nursing.

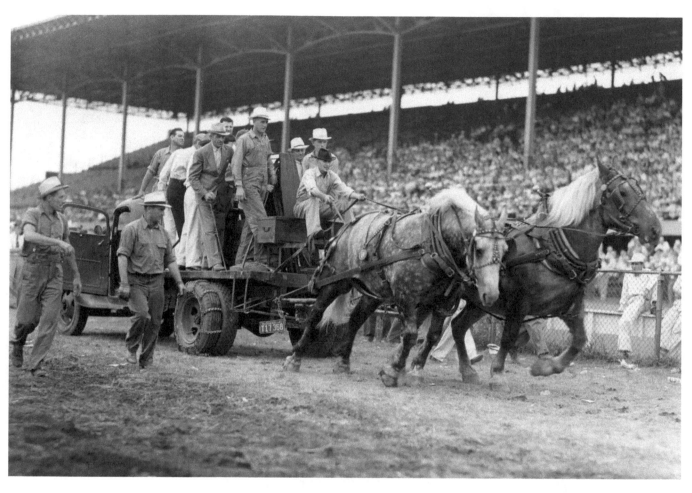

Farmers participate in a horse-pulling contest at the 1941 Indiana State Fair.

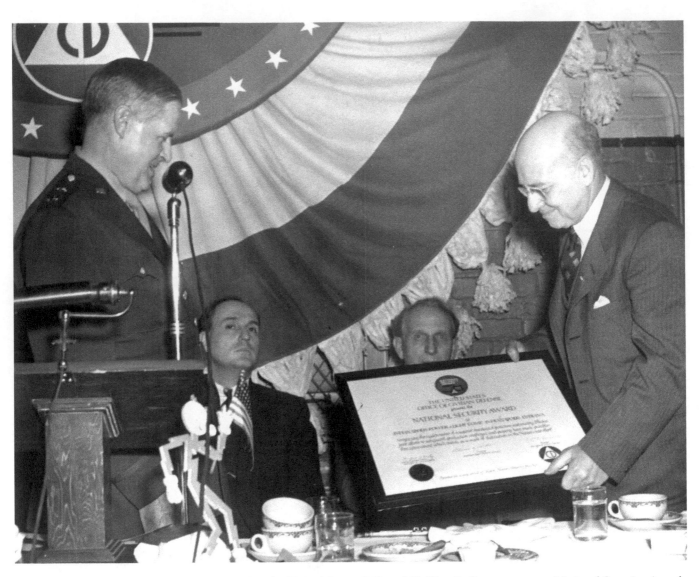

Major General Ulysses S. Grant III, representing the United States Office of Civilian Defense, presents a National Security Award to H. T. Pritchard, president of the Indianapolis Power and Light Company, March 22, 1944. IPL received the award for its efforts to protect its employees and facilities from fire, sabotage, air raids, and accidents during World War II.

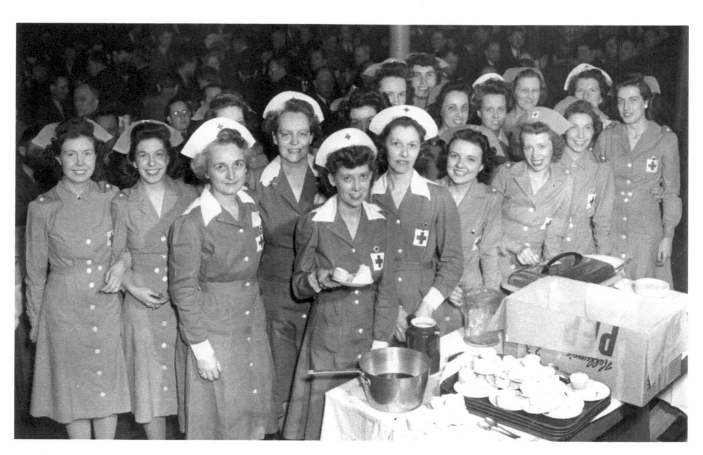

Red Cross volunteers staff a World War II canteen, 1944.

A parade on Monument Circle. Judging from the size of the crowd, the military uniforms, and the large amount of confetti, this was likely a veterans' parade, perhaps one to welcome home soldiers after World War II.

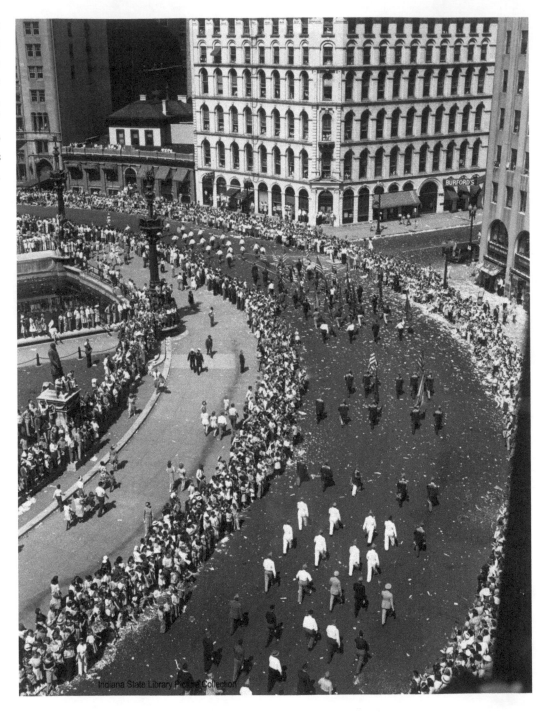

Indiana State Library Picture Collection

A view of University Park from the Blacherne apartment building, June 9, 1947. When Alexander Ralston laid out Indianapolis, he created University Square (as it was originally known) with the understanding that it would become the site of a state university. None ever opened there, but the land did house the Marion County Seminary from 1833 to 1853 and Indianapolis's first high school from 1853 to 1858. Troops drilled on the ground during the Civil War, and in 1876 the city opened it as a park. Today University Park is noted for its statuary and the Depew Fountain, which serves as its centerpiece.

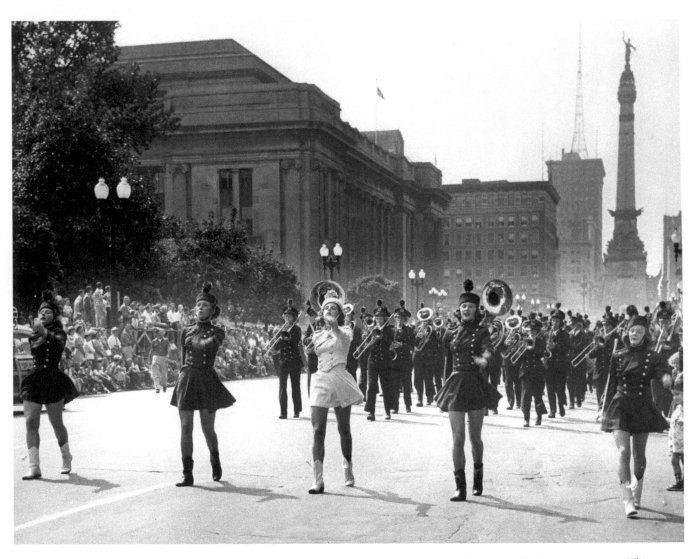

A high school band parades up North Meridian Street in honor of the Indiana State Fair's centennial, August 29, 1952. Thirty-eight more Indiana high school bands joined the procession, held on the fair's opening day, while 70,000 spectators cheered from the sidelines.

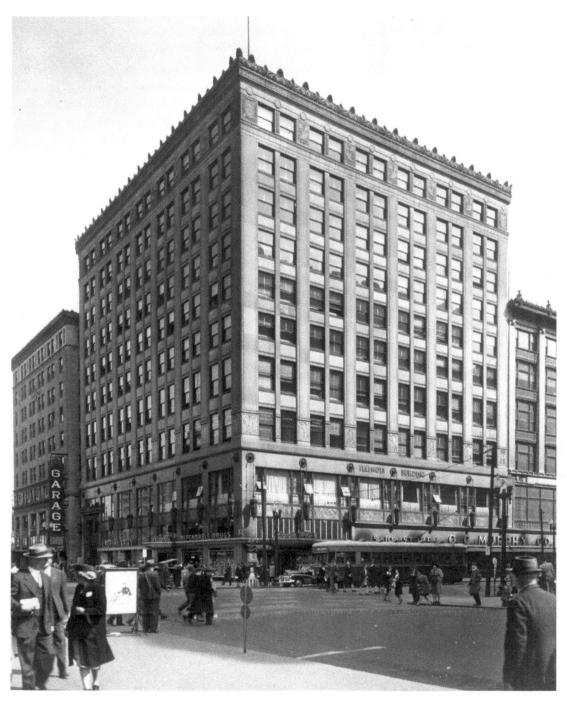

The Illinois Building, 1947. Leading Indianapolis architects Rubush and Hunter designed this ten-story edifice, which opened in 1925 on the southeast corner of Market and Illinois streets. Though structurally sound, it sits vacant today, with some interest expressed by developers in renovating the structure. The Historic Landmarks Foundation of Indiana named the Illinois Building one of its ten most-endangered landmarks for 2006.

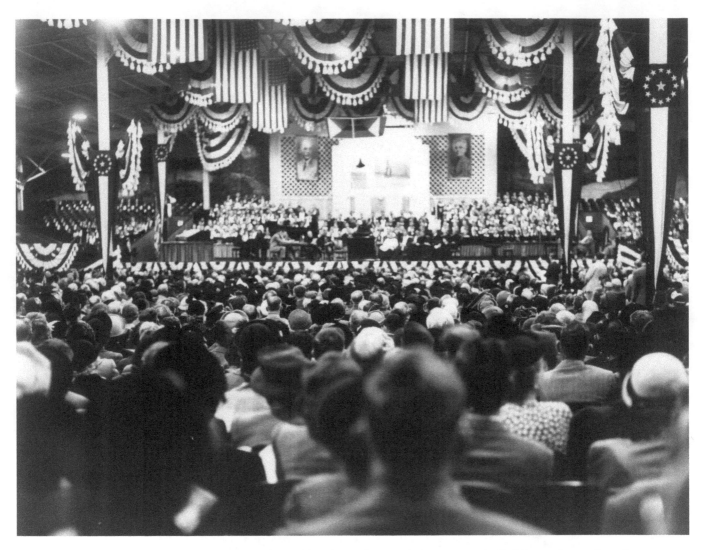

Church Federation Reformation Day services at the Cadle Tabernacle, October 29, 1950. Cadle Tabernacle stood on the northwest corner of Ohio and New Jersey streets from the early 1920s to the late 1960s. E. Howard Cadle built it for the promotion of Christianity. In the 1930s, he broadcast a popular evangelical radio program, the *Nation's Family Prayer Period*, from the site, and over the years well-known preachers such as Aimee Semple McPherson and Billy Sunday preached there. In addition to religious activities, the tabernacle hosted cultural and civic convocations.

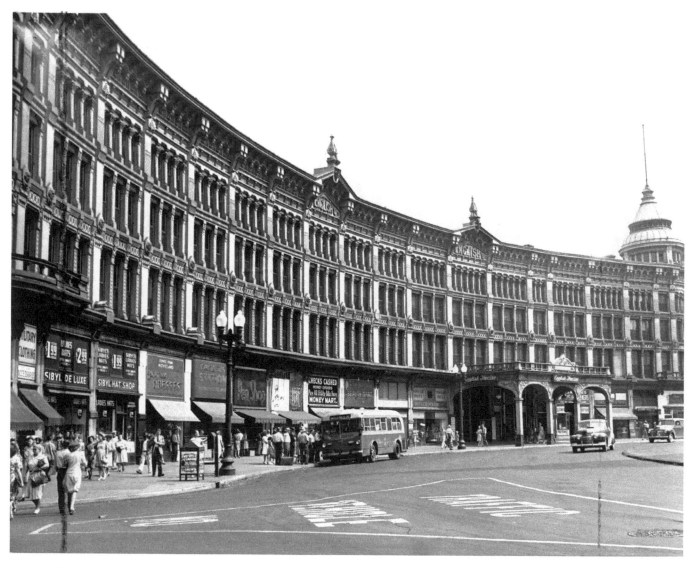

The English Hotel and Opera House, circa 1948. Prominent Indianapolis businessman (and Democratic vice-presidential nominee) William H. English opened a theater on the northwest quadrant of Monument Circle in 1880. Modeled after New York's Grand Opera House, it drew the leading performers of the day. Four years later English built a hotel onto the theater, and his son added another hotel section in 1896. For many years the hotel was one of the most fashionable in the city, but years took their toll, and by the mid twentieth century both it and the theater were in disrepair. Wrecking crews demolished the English in early 1949.

The intersection of Washington and Meridian streets, early 1950s. This view shows the "Crossroads of America," and in it is seen two of Indianapolis's competing department stores. On the right is H. P. Wasson and Company, which operated on or near the corner from 1883 until 1979. Across the street and dominating this photo is L. S. Ayres and Company, the city's most prominent retail establishment. Ayres opened this building in 1905 and remained here until early 1992, when its out-of-town owner, the May Company, decided to close the downtown store. Parisian department store now operates out of the building, which is part of Circle Centre Mall. Federated Department Stores acquired the May Company in 2005 and in late 2006 rebranded all remaining suburban Ayres stores as Macy's, obliterating the proud Ayres name from Indianapolis's retail landscape.

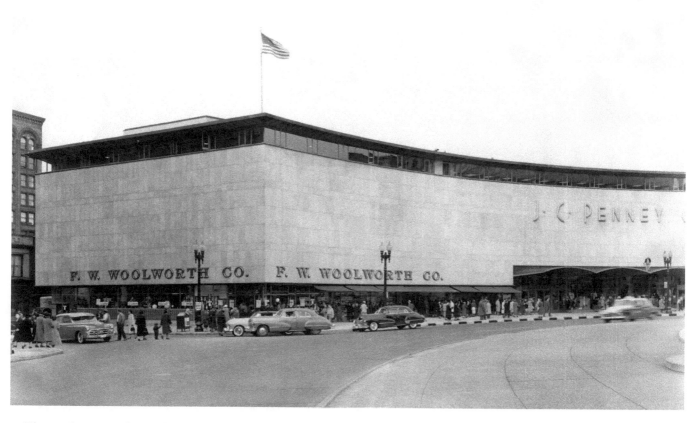

The northwest quadrant of Monument Circle in the 1950s. Developers tore down the English Hotel and Opera House to make way for this building, which housed J. C. Penney and F. W. Woolworth stores. Though many over the years have lamented the loss of the English, famed architect Frank Lloyd Wright praised the Penney building during a 1950s visit, saying it was one of the best examples of architecture in the city.

Workers assemble telephones at Western Electric on Indianapolis's east side, circa 1950s. Located on Shadeland Avenue, the Western Electric plant was the world's largest telephone factory. It covered 40 acres and at one time employed some 8,000 people. After 35 years of operation, the plant closed in 1985, the result of changing technology and declining business.

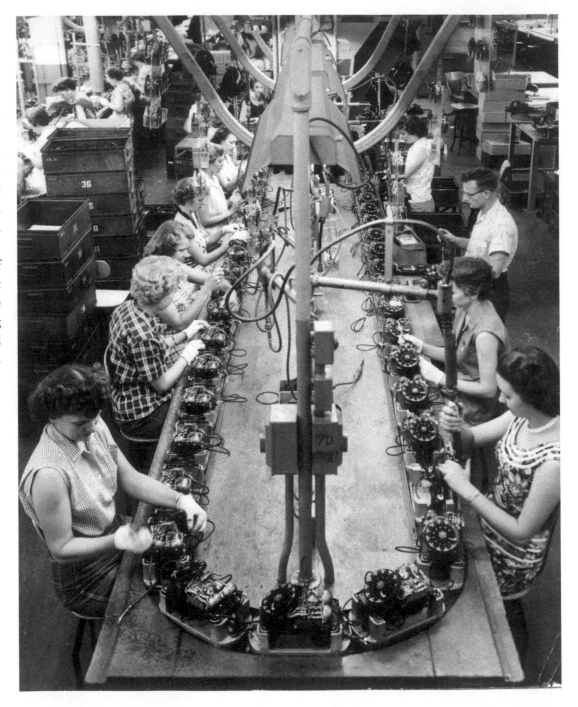

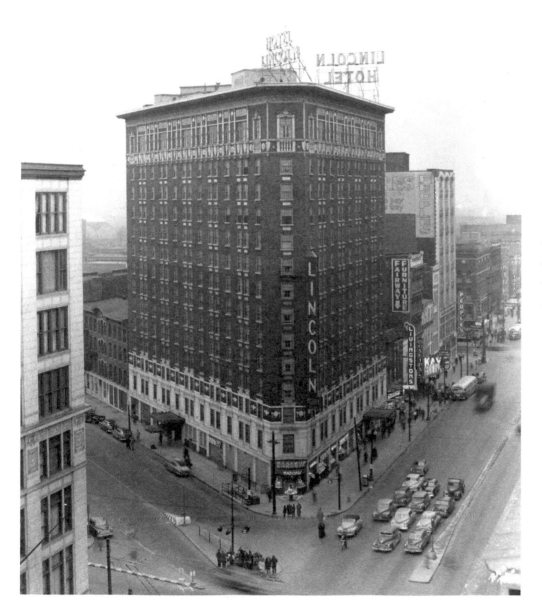

The Lincoln Hotel, circa 1950s. This 14-story flatiron hostelry stood at the corner of Washington Street, Illinois Street, and Kentucky Avenue. The entire intersection is now gone. At one time all four of Indianapolis's angling avenues ran to within one block of the circle, but in the early 1970s city leaders began allowing developers to cut them off and build over them, destroying the beauty and symmetry of Indianapolis's original plan. The Lincoln Hotel was a victim of this, felled by a wrecking ball in 1973 to make way for the Merchants Plaza.

The tower of the Marion
County courthouse soars over
East Washington Street.

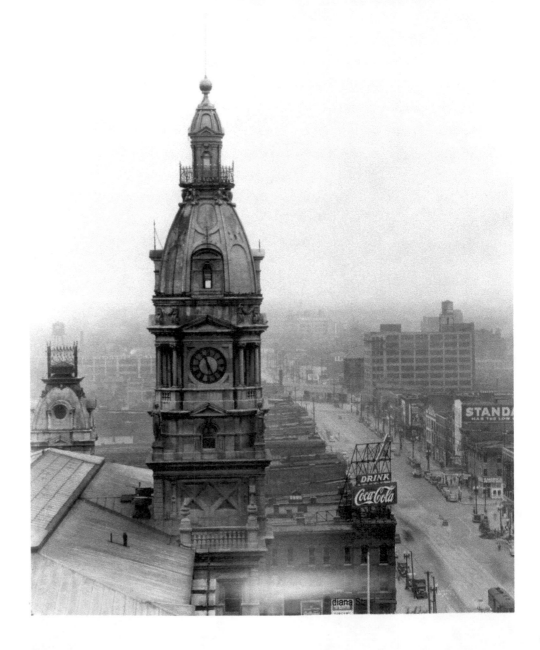

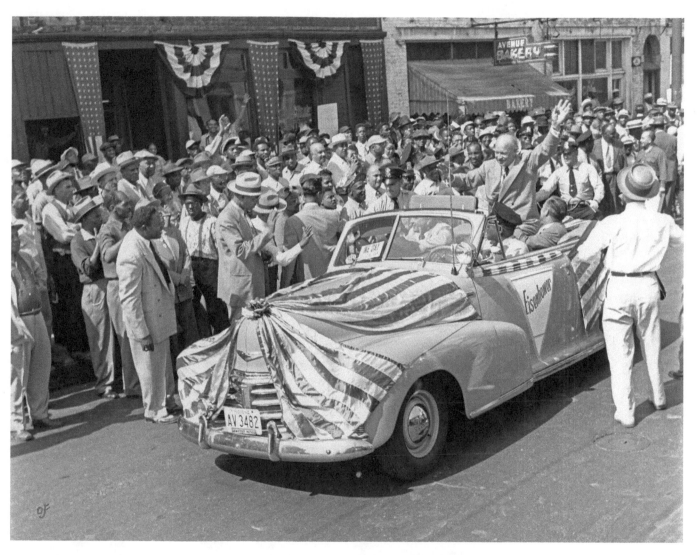

General Dwight D. Eisenhower campaigns in Indianapolis, 1952. In this photo, Eisenhower parades along Indiana Avenue, in the heart of the city's African-American community. Eisenhower defeated Adlai Stevenson to win the presidency that November.

Washington Street at night,
1958. This view looks
east from the roof of the
Lincoln Hotel.

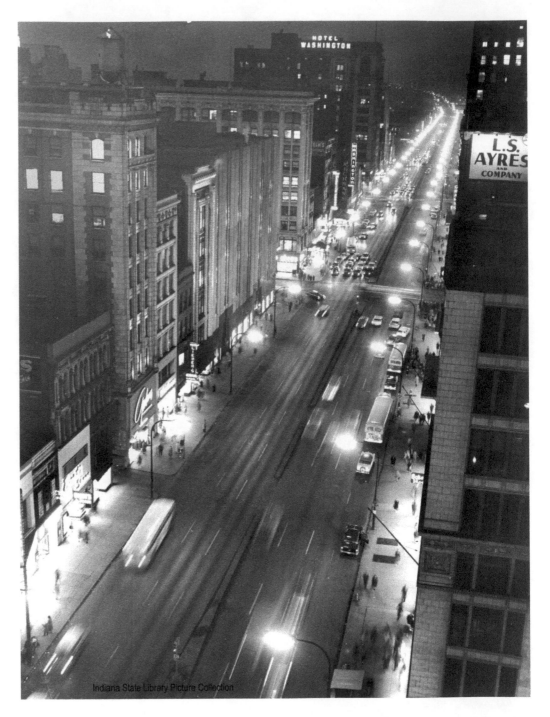

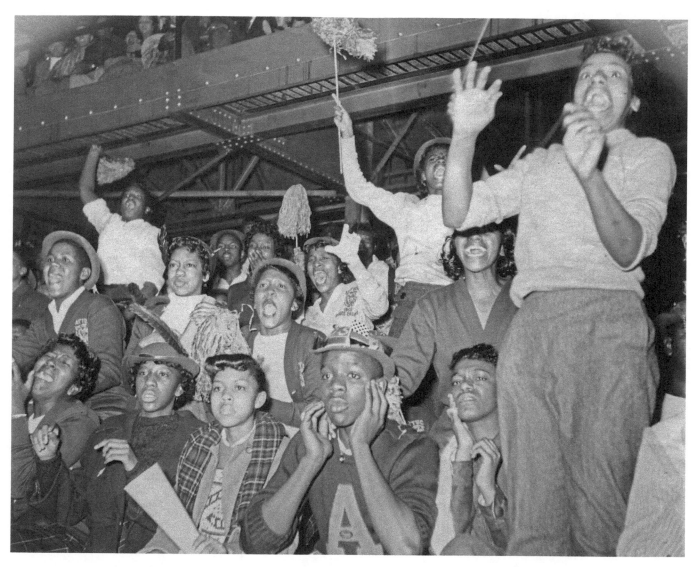

Fans cheer during a Crispus Attucks High School basketball game, 1958. The Indianapolis public school board opened Attucks in 1927 in order to segregate the city's African-American high school students. Even though it received few resources, Attucks had some of the best teachers in Indianapolis, and its students benefited from a quality education. In the 1950s, its basketball team was a powerhouse, winning the state championship in 1955, 1956, and 1959. Though Attucks converted to a junior high in 1986, the school board plans to reopen it as a high school, with a curriculum focusing on medical sciences.

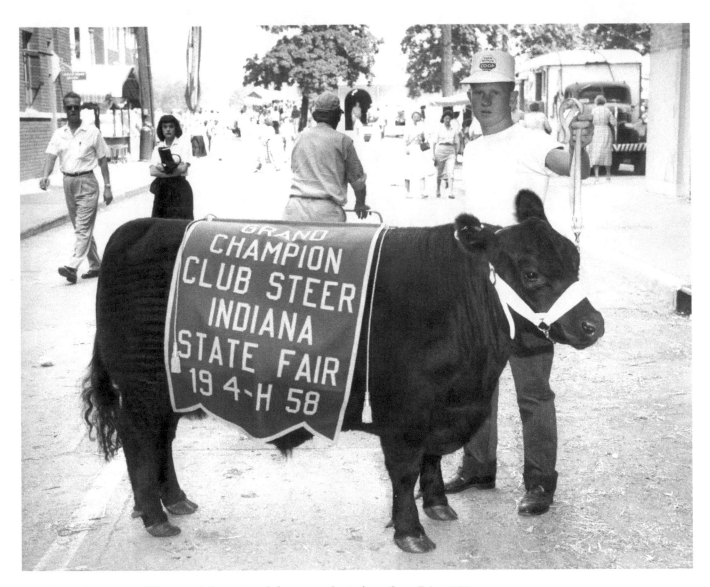

A 4-H member shows off his grand-champion club steer at the Indiana State Fair, 1958.

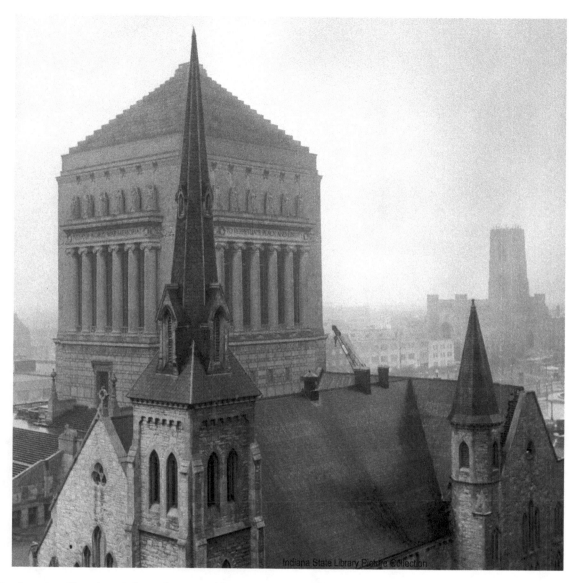

Indiana State Library Picture Collection

Second Presbyterian Church and the Indiana World War Memorial, 1960. Second Presbyterian, one of the city's oldest and most prominent churches, was founded in 1838. In the years after the Civil War it moved to the northwest corner of Vermont and Pennsylvania streets, in the neo-Gothic structure seen here. When construction on the war memorial began in 1926, most of the buildings on the block were demolished. Only Second Presbyterian and nearby First Baptist remained, and the memorial hovered over them for decades. Eventually the churches moved as well, and in 1960, presumably shortly after this photo was taken, they were torn down. Second Presbyterian now occupies a large French Gothic building in the 7700 block of North Meridian Street.

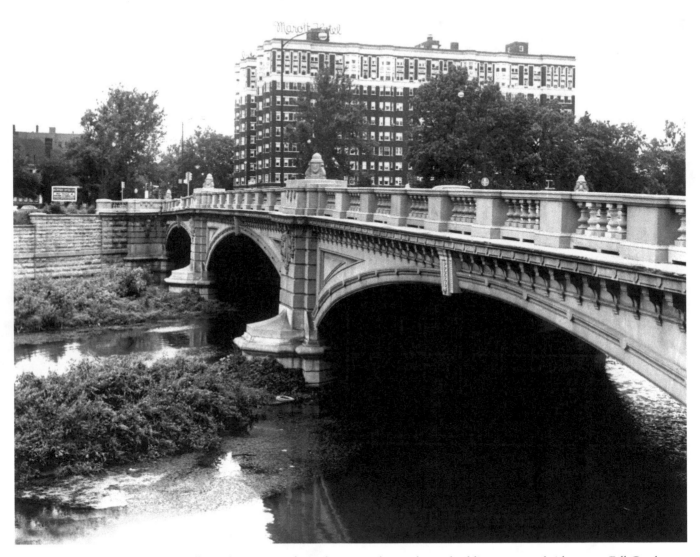

The Meridian Street bridge over Fall Creek, 1960. In the early 1900s, the city began building concrete bridges over Fall Creek, which resulted in rapid growth on the north side. The Meridian Street bridge was the most lavish. It was designed after the Victor Emmanuel II bridge over the Tiber River in Rome and today retains many of its original decorative features. The Marott Hotel stands in the background of this photo.

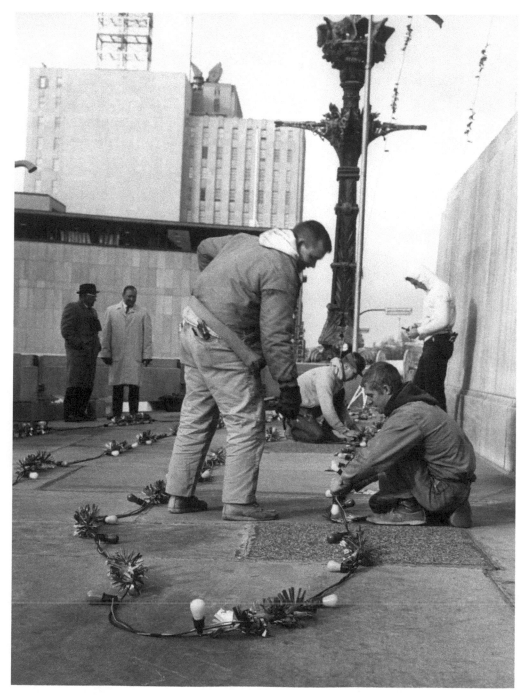

Workers prepare to string lights on the Soldiers and Sailors Monument, 1964. The city has decorated the monument with strands of lights since 1962, and each year the lighting ceremony, which takes place the day after Thanksgiving, draws tens of thousands of spectators.

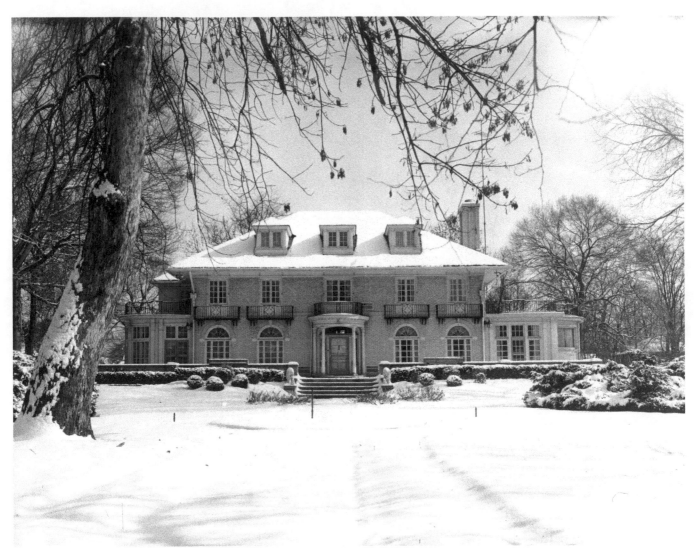

The Indiana governor's residence, 1963. This house, located at 4343 N. Meridian St., served as the fourth governor's residence from 1945 to 1973. William N. Thompson, head of the Stutz Motor Car Company, had it built in 1920. In the early 1970s, the state decided that the house was too small to accommodate the governor's family and allow for entertaining, so it bought another home, located a few blocks north near Meridian and Forty-sixth Street.

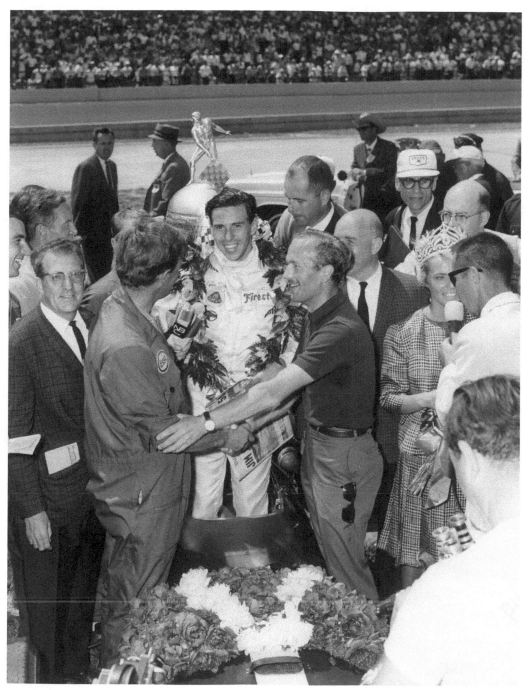

Jim Clark celebrates victory at the 1965 Indianapolis 500. Clark, a Scotsman, dominated the event, leading 190 of the 200 laps and sustaining a 150-mile-per-hour average. He died three years later at a Formula 2 race in Germany.

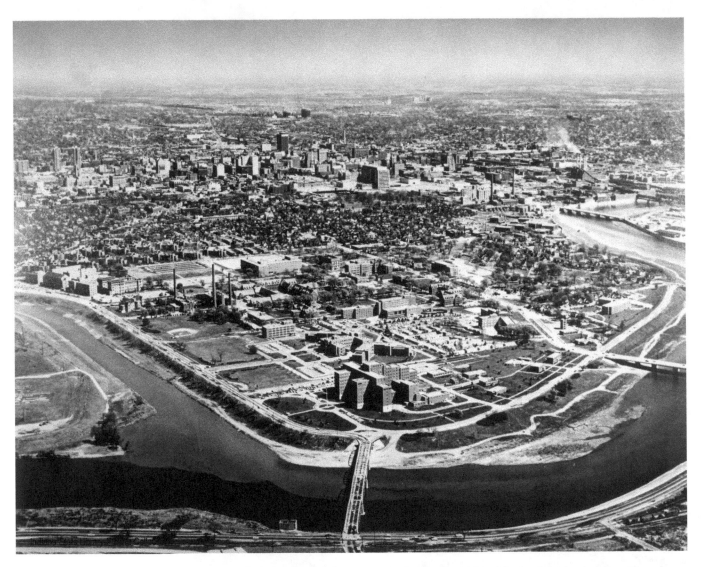

An aerial view of the Indiana University Medical Center and downtown Indianapolis, 1960s. Much of the land surrounding the medical center has been developed for the campus of Indiana University–Purdue University Indianapolis, which was created when the Indianapolis branches of the two universities merged in 1969.

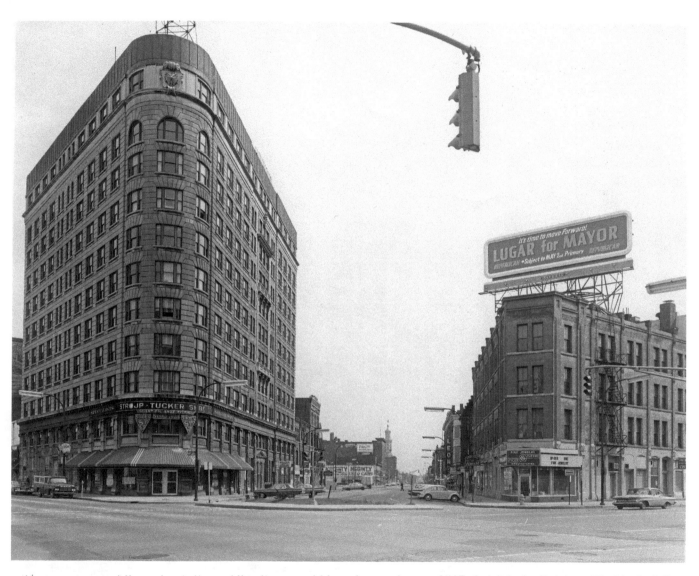

The intersection of Pennsylvania Street, Ohio Street, and Massachusetts Avenue, 1967. At left is the Knights of Pythias building, in its day one of Indianapolis's finest examples of flatiron architecture. It and the other buildings in the foreground were demolished soon after this photograph was taken in order to make way for the Indiana National Bank (today the Regions Bank).

The American Fletcher
National Bank and
Trust Company, 1968.
Chicago architects
Skidmore, Owings
and Merrill designed
this Monument Circle
building, the first
curtainwall structure
in Indianapolis, for the
Fidelity Bank and Trust
Company. By the time
the building opened
in 1959, however,
Fidelity had merged
with American Fletcher
National Bank, and the
structure served as an
addition to the main
AFNB headquarters,
seen here just to the east
on the northwest corner
of Pennsylvania and
Market streets.

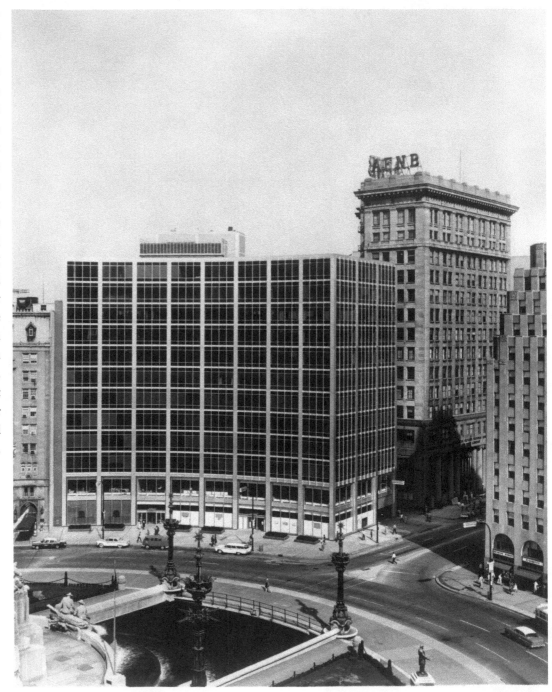

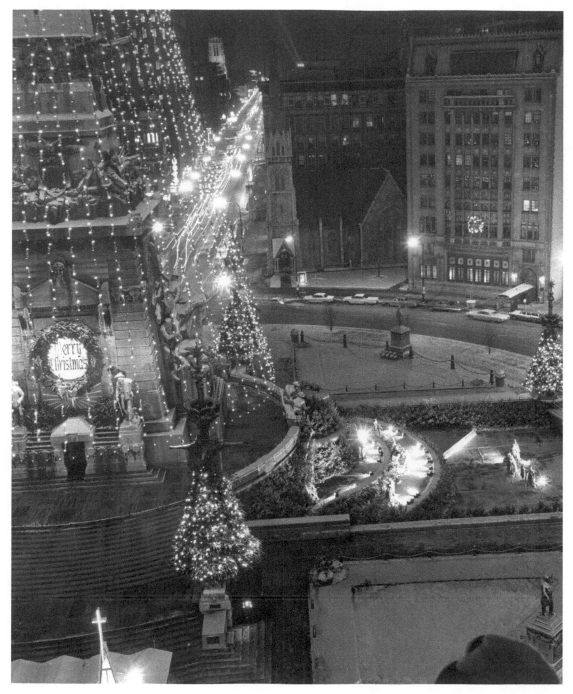

Christmas lights on the Circle Monument, circa 1960s. The monument's caretakers used to freeze water in the fountains and allow ice-skating during the holidays, but that practice ended when they discovered it was damaging the structure.

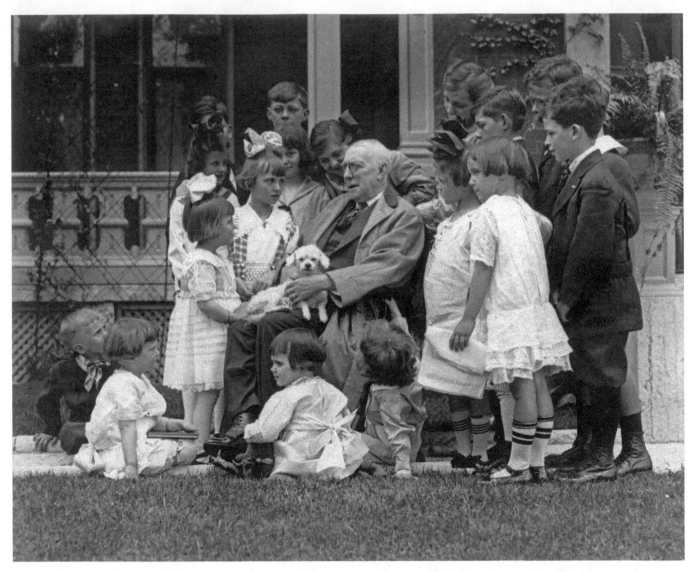

James Whitcomb Riley and children, 1916. Riley, one of the most popular poets in the late-nineteenth and early twentieth centuries, was well known for writing poems in the Hoosier dialect. Children especially loved him and were drawn to many of the characters he created, including Little Orphan Annie and the Raggedy Man. Here they gather around him and his dog Lockerbie on the lawn of his Indianapolis home. The photographer recorded this scene as Riley and the children were being filmed for a movie celebrating Indiana's centennial.

NOTES ON THE PHOTOGRAPHS

These notes, listed by page number, attempt to include all aspects known of the photographs. Each of the photographs is identified by the page number, a title or description, photographer and collection, archive, and call or box number when applicable. Although every attempt was made to collect all data, in some cases complete data may have been unavailable due to the age and condition of some of the photographs and records.

Printed in the USA
CPSIA information can be obtained
at www.ICGtesting.com
JSHW072024140824
68134JS00042B/3777